THE CIVIL WAR

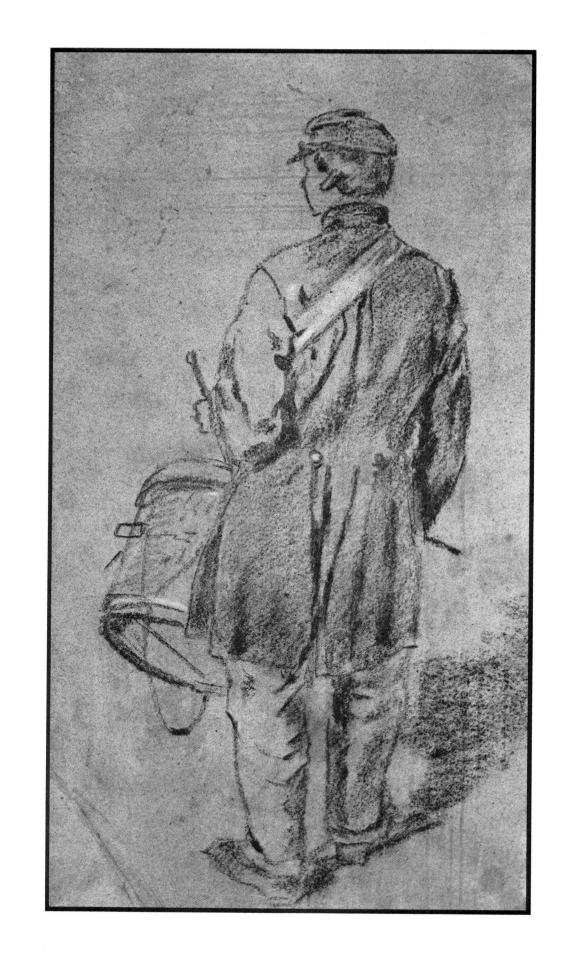

THE CIVIL WAR

Battlefields and Campgrounds

in the Art of Winslow Homer

BY JULIAN GROSSMAN

ABRADALE PRESS/HARRY N. ABRAMS, INC., PUBLISHERS, NEW YORK

To My Mother and Dad

Previously published as *Echo of a Distant Drum: Winslow and the Civil War*

1. Frontispiece. *Drummer Seen from the Back*. c. 1864. Charcoal and white chalk on blue paper, 16¾ x 11⅜″. Cooper-Hewitt Museum of Decorative Arts and Design, Smithsonian Institution, New York City
Note: Unless otherwise specified, drawings are on white paper

Ruth Wolfe, *Editor*
Dirk J. van O. Luykx, *Book Design*

ISBN 0–8109–8111–4

This 1991 edition is published by Harry N. Abrams, Incorporated, New York. A Times Mirror Company.
Printed and bound in Japan

CONTENTS

LIST OF PLATES

ACKNOWLEDGMENTS

Anyone who studies nineteenth-century American life as reflected in art must of necessity owe a great deal to the thoroughgoing scholarship and sympathetic art criticism of one man: Lloyd Goodrich, now Advisory Director of the Whitney Museum of American Art, New York City. His love for the art of Winslow Homer has acted as touchstone for my own appreciation.

My special thanks are due to Edgar M. Howell, Curator of Military History, Smithsonian Institution, the National Museum of History and Technology, Washington, D.C. In the true spirit of scholarship, Mr. Howell has kindly commented on the material aspects of details in certain fascinating Civil War drawings and paintings by Homer, thereby enhancing our knowledge in this area. Mr. Howell has generously allowed me to use his remarks in this book. Full credit is, of course, given him in each instance.

I am most happy to express my sincere appreciation for the consideration shown me by Mrs. Elaine E. Dee, Curator of Drawings and Prints, and indeed the entire staff of the Cooper-Hewitt Museum of Decorative Arts and Design, Smithsonian Institution, when on my visits I had the great personal pleasure and scholarly satisfaction of studying the original Winslow Homer Civil War drawings and sketches.

Dr. Philip C. Beam, Chairman of the Department of Art at Bowdoin College and a Homer scholar, was kind enough in the early stages of my study to suggest some sources which I might otherwise have overlooked.

To Mr. Kneeland McNulty, Curator of Prints and Drawings at the Philadelphia Museum of Art, I am indebted for strengthening the power

of my own convictions. Mr. McNulty, like all good art teachers, told me to follow my own style.

Muhlenberg College has awarded me a Muhlenberg College Humanities-Social Science Research Grant in partial support of the pursuance of this research. Dr. Victor L. Johnson, Chairman of the History Department at Muhlenberg, has read the first draft of the manuscript, and I have tried to profit from his kind suggestions.

And lastly, my thanks belong to my wife, Carolyn, a helpmate in the truest sense of the word.

J.G.

PREFACE

Up to this time there has been no thorough treatment of Winslow Homer's artistic portrayal of the Civil War. While doing graduate work in history I had occasion to write on American life in the nineteenth century as reflected in naturalistic art, and so I became aware of that gap in the literature. Since then I have dreamed of a comprehensive book on Homer's Civil War years. Those Civil War scenes which Winslow Homer, a young, sensitive eyewitness, documented so "simply, honestly and with such homely truth"[1] would not only be fascinating to the artlover but would also appeal to the student of American history.

The subject has been treated in one chapter of Lloyd Goodrich's standard biography of Winslow Homer. Some reproductions of the Civil War period are scattered through books by Lloyd Goodrich, Albert Ten Eyck Gardner, Hermann Warner Williams, Jr., Barbara Gelman, and others. But nowhere, until now, has the entire body of Winslow Homer's output on the Civil War been brought together chronologically and topically in one volume.

For the last six years I have studied in the original—or, where that proved impossible, in photographic reproduction—all extant Homer works done during 1861-65 or bearing on the Civil War: pencil, charcoal, crayon, and pen-and-ink drawings; wash and watercolor sketches; wood engravings, lithographs, and oil paintings. In my research I have sought to discover the historical significance of the art work, as well as to treat it appreciatively and aesthetically.

Art criticism starts with a paradox: to put into words the wordless. My

interpretations of the pictures are, of course, personal. I do not expect my readers to feel obliged to accept my value judgements but wish them to make their own evaluations. The aesthetic experience, for each individual, is the highest court of judgement. If the viewer is in emotional contact with the picture, the "shock of recognition" occurs.

Many of the original drawings and sketches are reproduced here for the first time. The atmosphere of the book is characterized most typically in Homer's poignant sketches, hauntingly delicate in hue. Stained here and there, faded now and again, they are often done in charcoal heightened with white chalk on beautiful blue paper.

Another important first is connected with the colorplates of the oil paintings. These are reproduced in sufficient size and detail to allow the reader to see facial expressions clearly and to follow Homer's excursions into psychological portrayal.

Basically, the book is arranged around the framework of the wood engravings, which are in strict chronological order, just as they appeared in *Harper's Weekly*. Within this framework illustrations on similar wartime topics are brought together and discussed. It is fascinating to see how Homer treated the same pictorial subject successively in different mediums, from an original sketch, worked up to a wood engraving, and finally through to the oil painting.

Lloyd Goodrich has written that "no other artist [than Homer] left so authentic a record of how the Civil War soldier really looked and acted."[2] Further, A. Hyatt Mayor, Curator Emeritus of Prints at the

Metropolitan Museum, writes: "Most old news illustrations interest us mainly as documents, but one is charmed by an artist's vision in Winslow Homer's pictorial reporting of American life at the time of the Civil War."[3]

It is an axiom of the historical method that the testimony of a contemporary eyewitness is a primary source and one to be trusted, especially when another eyewitness account independently corroborates the first. There exists written documentation of the Civil War which is, in many respects, the prose counterpart to Homer's pictorial record: Walt Whitman wrote down his firsthand impressions of the "war of attempted secession," which were published in 1875 under the title *Memorandum During the War* and were later incorporated into *Specimen Days*. The similarity in point of view is truly remarkable. Goodrich makes the observation that Homer "did for our painting what Walt Whitman did for our poetry—he made it native to our own earth and air."[4]

BACKDROP:

The Young Homer

Winslow Homer is, perhaps, our most popular American artist. He has immediate appeal to his countrymen, whatever their taste or artistic background may be. From his pictures we know what it feels like to be a child brought up in the country. This is our heritage: the mountains, the farmlands, the woods, the sea. We all know and appreciate the paintings and watercolors of that Homer. But few Americans, except art connoisseurs, know the young Homer.

Homer's young manhood and the political upheaval among the American states occurred simultaneously. Destined to become an artist of the highest stature and already possessing the full powers of a skilled illustrator, Homer documented the Civil War. His days as a solitary stag of art lay in the future. We can see by his choice of pictorial subjects that the lonely life we have come to associate with him had not begun. Never again was he to be so drawn into the life of his fellow men.

This is not to say that Homer made an abrupt about-face after the war. Whoever studies the body of his work will detect the continuous theme running through it. The young Homer was fascinated by the ceaseless activity of man and depicted him working, playing, and fighting. Later Homer, out of the depth of his experience, found his way to all nature—country meadows, sun-dappled woods, and blue lakes. One of his favorite themes was the image of man pitting his skill against the sea, and toward the last he was to paint the ebb and flow of the sea itself.

It has seemed to me that a gap exists in the study of Homer's artistic development, and that an examination of his total oeuvre on the Civil War

is necessary, particularly since the artist was not given to saving any material pertaining to his career and wanted his pictures to speak for him. Artlovers will appreciate Homer's young, vigorous draftsmanship and will delight in the original studies, so strong and vital in line and execution. They will note, perhaps with some surprise, the first, struggling use of color for simple visual identification by a man who was later to discover all the potential for luminous contrast in watercolor. They will see that Homer's assured use of simple washes presaged his mastery in the handling of watercolor. Finally, they will learn the meaning of craft acquired through experience when they see Homer's first attempts at oils.

At the time of the Civil War, established institutions were not prepared to meet new social pressures. Men stopped communicating and started shooting. Sympathetic study of a sensitive observer's portrayal of the Civil War can throw light on this national enigma, which still fascinates historian and public alike. There is evidence that some of Homer's contemporaries realized the historical value his simple, honest pictures would have for future generations of Americans. To gain new insight, we must trust the young Homer completely, seeing people through his eyes and accepting his depictions of inner character as fully as we accept his later impressions of the world around us.

Posing the question "How does an artist react to war?" is equivalent to asking, "What is the response to war of everything humane and sensitive in man?" Homer would not have been a man of his times if he had not at first reacted positively to the thrilling aspects of battle. Then, like other sensitive artists, he turned away from the face of death, away from

the front, to scenes in camp, concentrating on the camaraderie formed during trials suffered together.

In all Homer's wartime scenes there is greater individuality of expression than in comparable peacetime scenes—for instance, a crowd at play. People who are facing danger lose their inhibitions and allow their honest feelings to show. Homer rendered these facial expressions faithfully.

During the Civil War, Homer's strength lay in graphic depiction, as it did, basically, all his life—not so much in the sense that his pictures always tell a story, but more in the sense that there is always something being *done* in them. One critic has described Homer's early illustrations for *Harper's Weekly* as having "incisiveness," "strength," and "sincerity."[5] During the Civil War years of sketching human action, he was laying the basis for his later watercolor technique, which he would use to record his impressions of nature with great accuracy of line and tone value. It must be remembered that he was a good draftsman before he became a good painter.

I believe that the influence of Homer's mother, a talented amateur watercolorist, cannot be overestimated. Homer's first drawings, when he was only ten, were copies of his mother's work, and the amazing thing is that the feeling for the line is already there. His apprenticeship at Bufford's lithography shop in Boston from 1854 to 1857 and his early work as a free-lance illustrator must have developed still further this innate sense of line.

In 1859, at the age of twenty-three, Homer came to New York to seek his

fortune, like many another. He left behind him the New England he had loved and portrayed: fashionable Boston promenades and homelier montages of country games and family get-togethers at Thanksgiving and Christmas. He took along with him to *Harper's Weekly*, the leading illustrated review of the day, a style characterized by what can only be called the definitive line. Even this early, Homer also showed an interest in capturing the look of natural lighting.

During the year 1860 he attended a drawing school in Brooklyn, the only type of formal art study available in the United States and also his first formal training; then he worked in the National Academy of Design night school. Painting was not taught there, only drawing, and even that was done from casts; no life class was offered. This must have been a frustrating experience for one whose skill lay in portraying movement and fleeting expression. It was not until the age of twenty-five that Homer plunged into the technique of oil painting as a medium that afforded greater depth. His career as an illustrator evidently was not bringing him enough satisfaction. In 1861 he took about five lessons from Frédéric Rondel, a French painter resident in New York, on how to handle his brush, set up his palette, and so on, but as far as we know he produced no oils before the final months of 1862. If we can say that any artist was self-taught, that artist was Homer.

CHRONOLOGY

1836 February 24. Born in Boston

1857 August 1. First illustration in *Harper's Weekly*

1859 Autumn. Moves to New York City

1860 Attends drawing school in Brooklyn

1861 Changes residence to New York University Building, where he has studio in tower room
Studies briefly in National Academy of Design night school
March 4. Covers Lincoln's inauguration for *Harper's Weekly*
April 12. Fort Sumter bombarded by Confederate shore batteries and forced to surrender
Spring. Spent in New York City
Summer. Spent with family in Belmont, outside Boston
July 21. First Battle of Bull Run
October. Makes first trip to the front as "Special Artist" for *Harper's*, staying with Army of the Potomac
Elementary painting lessons from Frédéric Rondel

1862 March 9. U.S.S. *Monitor* and C.S.S. *Virginia (Merrimac)* meet off Hampton Roads in first naval engagement between ironclad vessels
April 1 through early May. With McClellan's army on Peninsular campaign

September 23. Lincoln issues Emancipation
Proclamation
Paints first adult oil, *Sharpshooter*

1863 January through February. In all probability made trip
to the front. Now a free-lance artist
July 1. Battle of Gettysburg begins

1864 May 5-7. With Grant's army during Battle of the
Wilderness
Winter. At siege of Petersburg

1865 March. With Union army on what is to be its last
campaign
April 9. Lee surrenders to Grant at Appomattox
April 14. President Lincoln assassinated
Elected National Academician

1866 *Prisoners from the Front* completed
Sails for France*

*Sources for Chronology:
Lloyd Goodrich, *Winslow Homer* (New York: Macmillan, 1944); Mary Bartlett
Cowdrey, *Winslow Homer: Illustrator* (Northampton, Mass.: Smith College
Museum of Art, 1951); *The Civil War: A Centennial Exhibition of Eyewit-
ness Drawings* (Washington, D.C.: National Gallery of Art, Smithsonian In-
stitution, 1961); *Facts about the Civil War*, prepared by the Civil War Cen-
tennial Commission (Washington, D.C.: Government Printing Office, 1960).

THE CIVIL WAR

PART 1

THE FIRST YEARS OF WAR

1860-1862

2. *Union Meetings in the Open Air Outside the Academy of Music.*
Published in *Harper's Weekly*, January 7, 1860. Wood engraving, 10 3/4 x 9 1/4''.
The Metropolitan Museum of Art, New York City. Harris Brisbane Dick Fund, 1929

What were the causes of the Civil War? Historians may never know absolutely. Was slavery really the single cause? Certainly economic rivalry was also part of the clash of sectionalism. Political thinking pitted the doctrine of States' Rights against the strength of the Federal Constitution, coalescing all the feelings involved in the question of minority rights under majority rule. No one could sanely deny that there were failings on both sides.[6] Moral, political, economic, social, and personal factors all entered into the conflict.

When Winslow Homer moved to New York in the fall of 1859 to pursue his career as a free-lance magazine illustrator, he found the city in ferment over the great issues that were inexorably dividing the nation. On January 7, 1860, a public debate on the issues of slavery and the preservation of the Union was held at the Academy of Music, accompanied by huge open-air meetings. Some ten thousand people gathered in what *Harper's Weekly* reported to be the most enthusiastic meetings that could be remembered up to that time:

Long before the hour for meeting the spacious Academy was thronged from pit to dome.... The Academy had been appropriately decorated for the occasion. The Stars and Stripes hung in graceful folds about the stage, and at different points were mottoes and inscriptions, and the names of those who in the past consecrated their lives to the formation and perpetuation of the institutions of our country....

Numerous delegations of citizens from other cities were present, and participated in the enthusiasm of the occasion; and throughout, the proceedings were characterized by the most perfect harmony and good feeling in favor of the object which had called the vast assemblage together.

... Mr. Brooks spoke briefly, defending the rectitude and purity of Northern sentiment and exalting the value of the Union. Mr. Charles O'Conor followed with an eloquent eulogy of Slavery, which was not listened to without expressions of dissatisfaction from a portion of the audience.... The outside meetings were highly interesting, several speakers of distinction and popularity engaging the attention of the several groups.

An illustration by Homer accompanied the *Harper's* article. In his scene of the meeting outside the Academy, fireworks light up the night sky and a blazing bonfire billows bright flame and floating smoke. This occupies the right side of the picture. But on the left side, how fares it? The serious stillness of the crowd reflects the crisis that has been reached.

A braham Lincoln made an address at Cooper Institute in New York City on February 27, 1860. His words reflected the mood of the North.

Holding, as they [the Southern people] do, that slavery is morally right and socially elevating, they cannot cease to demand a full national recognition of it as a legal right and a social blessing.

Nor can we justifiably withhold this on any ground save our conviction that slavery is wrong. If slavery is right, all words, acts, laws, and constitutions against it are themselves wrong, and should be silenced and swept away. If it is right, we cannot justly object to its nationality—its universality; if it is wrong, they cannot justly insist upon its extension—its enlargement. All they ask we could readily grant, if we thought slavery right; all we ask they could as readily grant, if they thought it wrong. Their thinking it right and our thinking it wrong is the precise fact upon which depends the whole controversy. Thinking it right, as they do, they are not to blame for desiring its full recognition as being right; but thinking it wrong, as we do, can we yield to them? Can we cast our votes with their view, and against our own? In view of our moral, social, and political responsibilities, can we do this? . . .

Neither let us be slandered from our duty by false accusations against us, nor frightened from it by menaces of destruction to the government, nor of dungeons to ourselves. Let us have faith that right makes might, and in that faith let us to the end dare to do our duty as we understand it.[7]

28

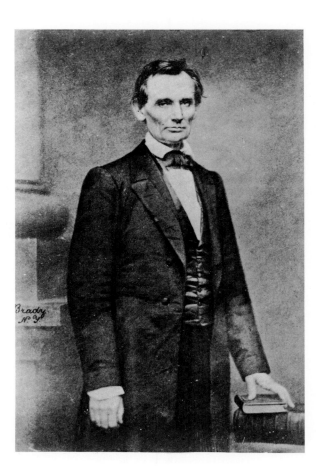

3. Mathew B. Brady.
The Cooper Institute Portrait of Abraham Lincoln.
February 27, 1860. Photograph.
Library of Congress,
Washington, D.C.

4. Preston Butler.
Abraham Lincoln.
August 13, 1860.
Photograph of ambrotype.
Library of Congress,
Washington, D.C.

Prior to his election, Lincoln's face was unbearded. This is the way he appeared in the portrait photograph taken by Mathew Brady in New York on the day of the Cooper Institute speech. The photograph by Brady, known as the Cooper Institute portrait, was widely distributed during Lincoln's campaign, along with two others taken by Brady the same day. The Cooper Institute speech and these photographs undoubtedly helped Lincoln win the election.[8]

Homer's portrait of Lincoln, a wood engraving signed with the artist's "H" in the lower right-hand corner, was obviously copied from the Brady photograph; but in drawing the portrait on the wood-engraving block, the artist took certain liberties. In place of the stark background common to a photographer's studio, Homer placed Lincoln in front of an open window with a wild grapevine growing over the sill and a view of a herd of buffalo on the endless prairie in the distance. Since *Harper's Weekly* had a circulation of over one hundred thousand, Homer's interpretation of Lincoln also helped to make the candidate's features more familiar to his countrymen.[9]

Even the best portraits of Lincoln, including Homer's, make him look rather stiff. Sandburg, pointing to the historical evidence, declares that Lincoln's facial expression was actually quite mobile.[10] John Nicolay, Lincoln's private secretary, said his looks depended upon his mood, and that his features were always modified by his emotions.[11] Horace White of the Chicago *Tribune* told of the smile that transfigured Lincoln's face and of the sparkle that came into his eyes when he talked to people.[12]

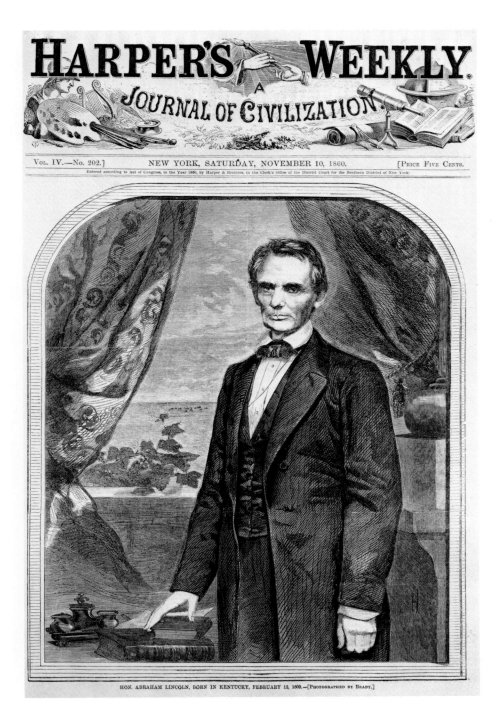

5. *Hon. Abraham Lincoln, Born in Kentucky, February 12, 1809.* Published in *Harper's Weekly*, November 10, 1860. Wood engraving, 10 1/2 x 9 1/4″. The Metropolitan Museum of Art, New York City. Harris Brisbane Dick Fund, 1929

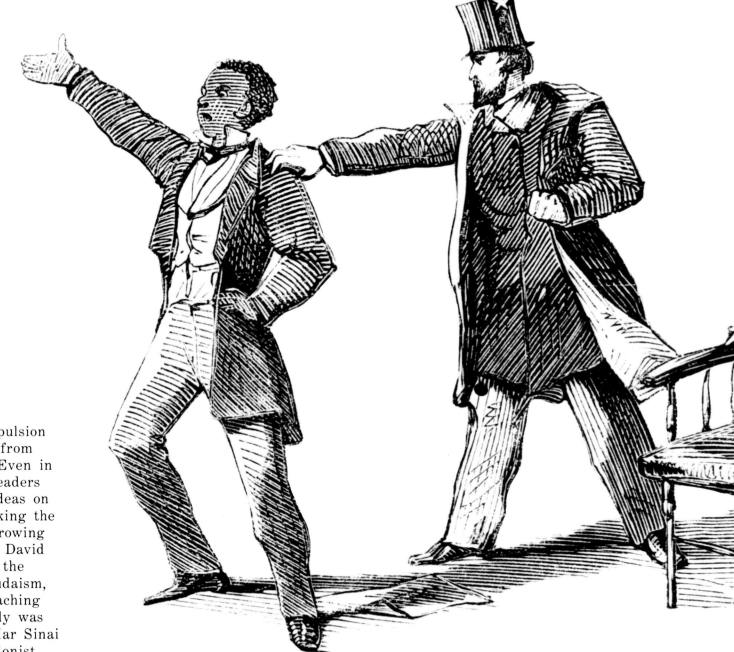

30 **H**omer portrayed the expulsion of Negroes and abolitionists from Tremont Temple in Boston. Even in the border states, religious leaders were disseminating radical ideas on the slavery question and making the pulpit a focal point of the growing conflict. In Baltimore, Rabbi David Einhorn, the great leader of the Reform wing of American Judaism, was directed to stop his preaching against slavery and eventually was forced to leave his post at Har Sinai Temple because of his abolitionist writings. He, like many others, held that slavery was incompatible with the teachings of the Bible.

6. *Expulsion of Negroes and Abolitionists from Tremont Temple, Boston, Massachusetts,*
on December 3, 1860. Published in *Harper's Weekly*, December 15, 1860. Wood engraving, 6 ⁷/₈ x 9 ¹/₄″.
The Metropolitan Museum of Art, New York City. Harris Brisbane Dick Fund, 1928.
Detail opposite

32

7. *The Seceding South Carolina Delegation.* Published
in *Harper's Weekly*, December 22, 1860. Wood engraving,
10 ¹/2 x 9″. Library of Congress, Washington, D.C.

8. *The Georgia Delegation in Congress.* Published
in *Harper's Weekly*, January 5, 1861. Wood engraving,
10 ³/4 x 9 ¹/4″. The Metropolitan Museum of Art, New York City.
Harris Brisbane Dick Fund, 1929

The threat of secession had been the last resort of minorities from Revolutionary times. When Lincoln was elected, a state convention was called by the South Carolina legislature. On December 20, 1860, the delegates unanimously voted to dissolve the union between South Carolina and the other states. They acted on a tacitly held assumption that better terms could be obtained if secession were a reality, and that other states would follow South Carolina's lead. By February, 1861, six other states had seceded, among them Mississippi, on January 9, and Georgia, on January 19. *The Seceding Mississippi Delegation in Congress*, with its striking portrait of Jefferson Davis, was drawn by Homer from a Mathew Brady photograph.

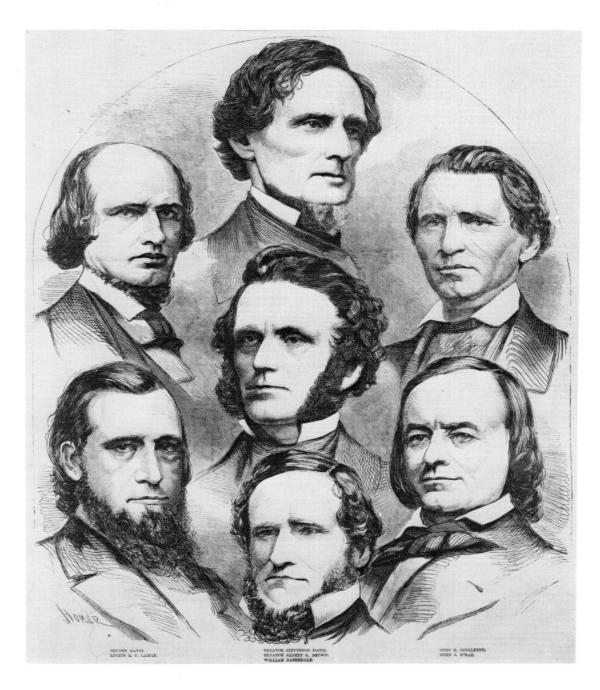

9. *The Seceding Mississippi Delegation in Congress.* Published in *Harper's Weekly*, February 2, 1861. Wood engraving, 9 1/8 x 10 7/8".
The Metropolitan Museum of Art, New York City. Harris Brisbane Dick Fund, 1929

As it did upon many that day, Lincoln's inauguration made a deep impression upon one Wilder Dwight, who was from an eminent Massachusetts family and major of the Second Massachusetts Infantry. Wilder described the scene to his father:

Washington, March 4, 1861

Dear Father,

The morning broke badly, but at noon the sky cleared. I remained quietly at Willard's, and was present when Mr. Buchanan came to receive the President elect, and saw the interview, which was a formal one; then I saw Lincoln and Buchanan take their carriage, and by back streets, reached the Capitol grounds, and got a good place.

Soon Lincoln and Judge Taney, followed by Buchanan and the other judges, etc. appeared. The band played Hail Columbia. The crowd was immense. The Capitol steps were covered with uniforms, etc. Baker, of Oregon, for the Committee of Arrangements, announced that Mr. Lincoln would speak; and when Abraham rose and came forward and rang out the words, "Fellow-citizens of the *United* States," he loomed and grew and was ugly no longer. I was not very near but heard him perfectly. The address you will read, and like, I hope. Its effect was very good. An immense concourse—thousands—stood uncovered and silent, except occasional applause; the voice clear and ringing; the manner very good, often impressive, and even solemn; the words I think to the point, direct and clear. The scene itself was of its own kind. And I must say its effect upon me was far greater than I had supposed.

When the address closed and the cheering subsided, Taney rose, and almost as tall as Lincoln, he administered the oath, Lincoln repeating it; and as the words, "preserve, protect and defend the Constitution" came ringing out, he bent and kissed the book; and for one, I breathed freer and gladder than for many months. The man looked a man, and acted a man and a President.[13]

34

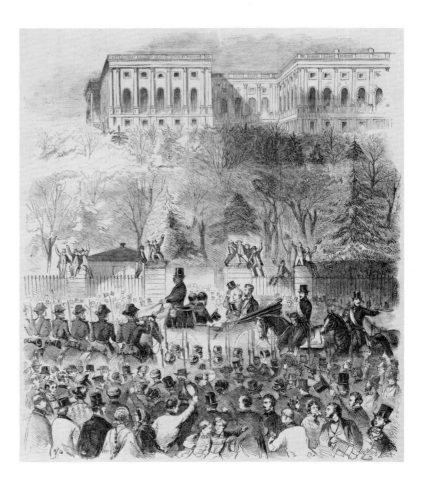

10. *The Inaugural Procession at Washington Passing the Gate of the Capitol Grounds.* Published in *Harper's Weekly*, March 16, 1861. Wood engraving, 10 7/8 x 9 1/8". The Metropolitan Museum of Art, New York City. Harris Brisbane Dick Fund, 1929

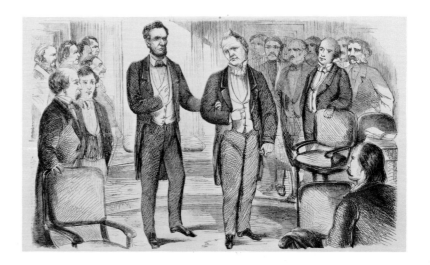

11. *Presidents Buchanan and Lincoln Entering the Senate Chamber Before the Inauguration.* Published in *Harper's Weekly*, March 16, 1861. Wood engraving, 5 7/8 x 9 1/8". The Metropolitan Museum of Art, New York City. Harris Brisbane Dick Fund, 1929

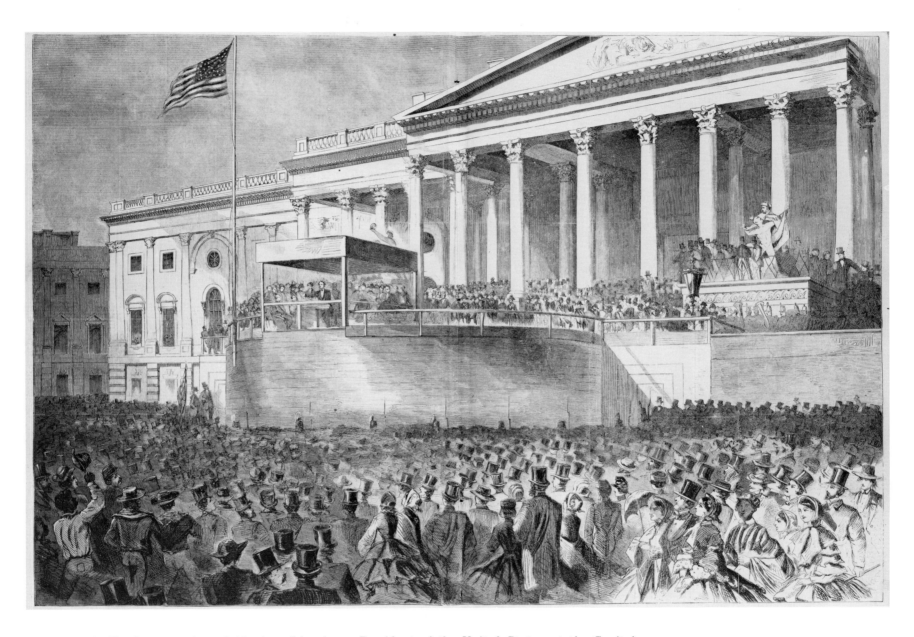

12. *The Inauguration of Abraham Lincoln as President of the United States, at the Capitol, Washington, March 4, 1861.* Published in *Harper's Weekly*, March 16, 1861. Wood engraving, 13 3/4 x 20 1/8″. The Metropolitan Museum of Art, New York City. Harris Brisbane Dick Fund, 1929

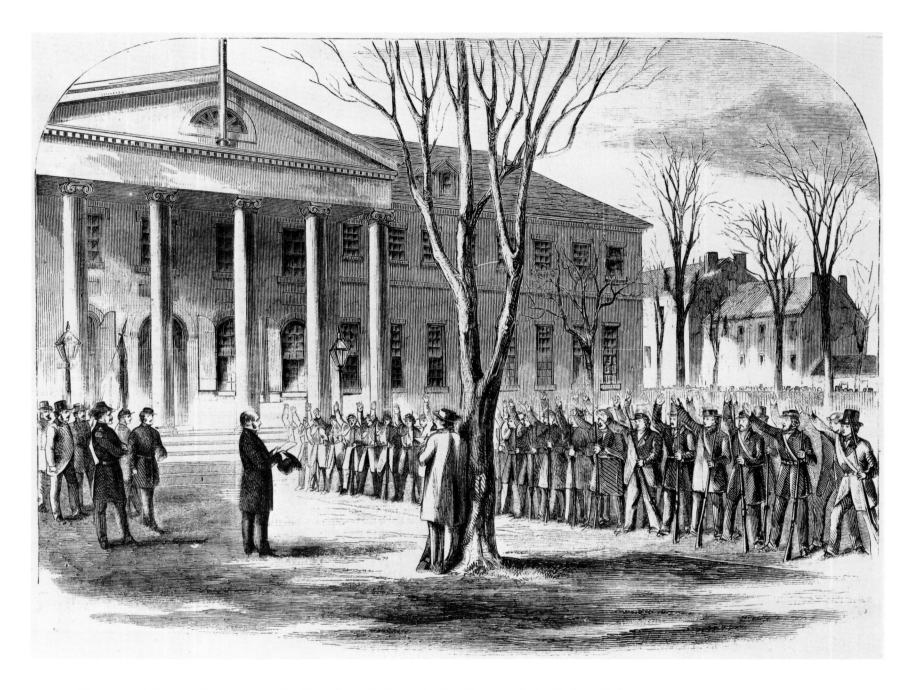

13. *General Thomas Swearing in the Volunteers Called into the Service of the United States at Washington, D.C.* Published in *Harper's Weekly*, April 27, 1861. Wood engraving, 6 3/8 x 9 1/8".
Prints Division, The New York Public Library. Astor, Lenox and Tilden Foundations

On April 14, 1861, the troops of the newly formed Confederacy, led by General P. G. T. Beauregard, attacked and captured Fort Sumter, off the South Carolina coast.

Lincoln called for volunteers to defend the Union. Men like William Wilson, a New York political figure, personally recruited nearly two thousand men for his brigade, known as Wilson's Zouaves. Accompanying his portrait, *Harper's* gave a sample of Wilson's recruiting technique. "You want to come with me, eh! Well, if you do, three-fourths of you will be in your graves in three weeks! 'Bravo! good! good!' was the unanimous reply. 'We'll go with you!' "[14]

Everywhere the response was the same. Wilder Dwight described the outpouring of patriotism:

The volcanic upheaval of the nation, after that firing on the flag at Charleston, proved for certain something which had been previously in great doubt, and at once substantially settled the question of disunion. In my judgment it will remain as the grandest and most encouraging spectacle yet vouchsafed in any age, old or new, to political progress and democracy. It was not for what came to the surface merely— though that was important—but what it indicated below, which was of eternal importance. Down in the abysms of New World humanity there had form'd and harden'd a primal hard-pan of national Union will, determin'd and in the majority, refusing to be tamper'd with or argued against, confronting all emergencies, and capable at any time of bursting all surface bonds, and breaking out like an earthquake. It is, indeed, the best lesson of the century, or of America, and it is a mighty privilege to have been part of it. (Two great spectacles, immortal proofs of democracy, unequall'd in all the history of the past, are furnish'd by the secession war—one at the beginning, the other at its close. Those are, the general, voluntary, arm'd upheaval, and the peaceful and harmonious disbanding of the armies in the summer of 1865.)[15]

14. *General Beauregard.* Published in *Harper's Weekly*, April 27, 1861. Wood engraving, 6 7/8 x 5″. The Metropolitan Museum of Art, New York City. Harris Brisbane Dick Fund, 1929

15. *Colonel Wilson, of Wilson's Brigade.* Published in *Harper's Weekly*, May 11, 1861. Wood engraving, 9 1/8 x 5 7/8″. The Metropolitan Museum of Art, New York City. Harris Brisbane Dick Fund, 1929

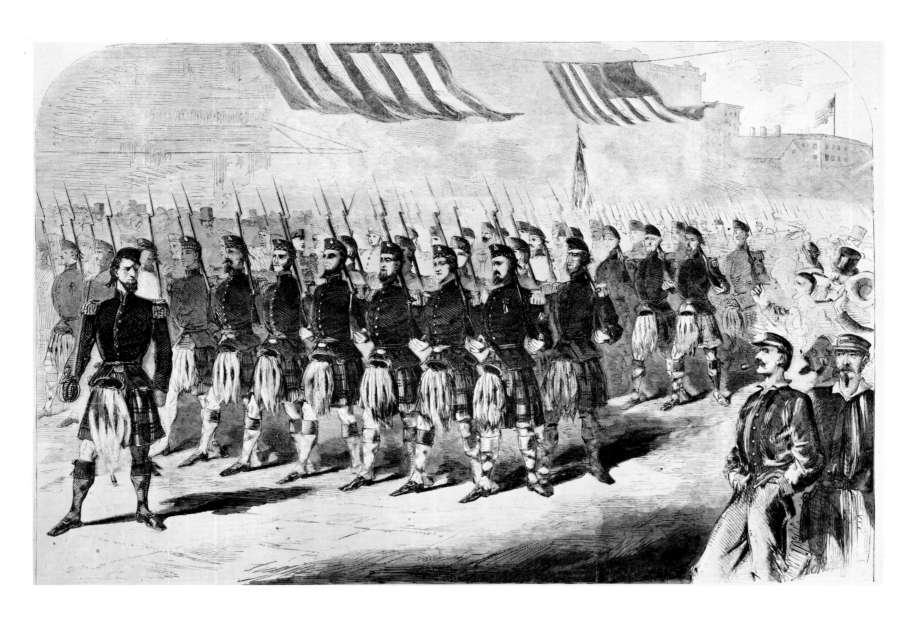

16. *The Seventy-ninth Regiment (Highlanders) New York State Militia.* Published
in *Harper's Weekly*, May 25, 1861. Wood engraving, 9 1/4 x 13 7/8". The Metropolitan
Museum of Art, New York City. Harris Brisbane Dick Fund, 1929

17. *The Advance Guard of the Grand Army of the United States Crossing the Long Bridge over the Potomac, at 2 A.M. on May 24, 1861.* Published in *Harper's Weekly,* June 8, 1861. Wood engraving, 9 1/8 x 14″. Prints Division, The New York Public Library. Astor, Lenox and Tilden Foundations

When the volunteers first went to war, the old independent companies still wore their impractical dress uniforms, as shown in *The Seventy-ninth Regiment (Highlanders) New York State Militia.* By the time these men of Scottish birth reached Bull Run, their kilts had been exchanged for Cameron tartan trews.[16] As in many of Homer's illustrations of this period, the composition is divided into the doers and the watchers, with the active figures occupying the center stage and the passive ones placed in the foreground corners to complete the image. In this particular scene the regiment leader serves as a spiritual and physical link between the intent, somewhat withdrawn volunteers and the appreciative civilian onlookers.

The story of this scene is told in a charming, candid, and semi-close-up composition typical of Homer. The pretty faces capture our attention at once. The main figure in the center appears to be intent upon her work, but she does it automatically. A serious look intimates that she is thinking about scenes far away—the war. The young lady on the right, closest to the viewer, impresses us as one who is doing all that a maiden can do to help in the war effort, while on our left a countenance of delicate sadness is hidden beneath a jaunty havelock. Each girl's facial expression is an individual reaction to the events of the time, but each one's hands are busy sewing, and Homer has woven them all together in an elegant, flowing, and harmonic structure. The heart may be sad and the mind troubled, but the hands must not be idle—a Victorian dictum, perhaps, but a practical one.

18. *The War—Making Havelocks for the Volunteers*. Published in *Harper's Weekly*,
June 29, 1861. Wood engraving, 10 ⅞ x 9 ¼″. The Metropolitan Museum of Art, New York
City. Harris Brisbane Dick Fund, 1929. Detail opposite

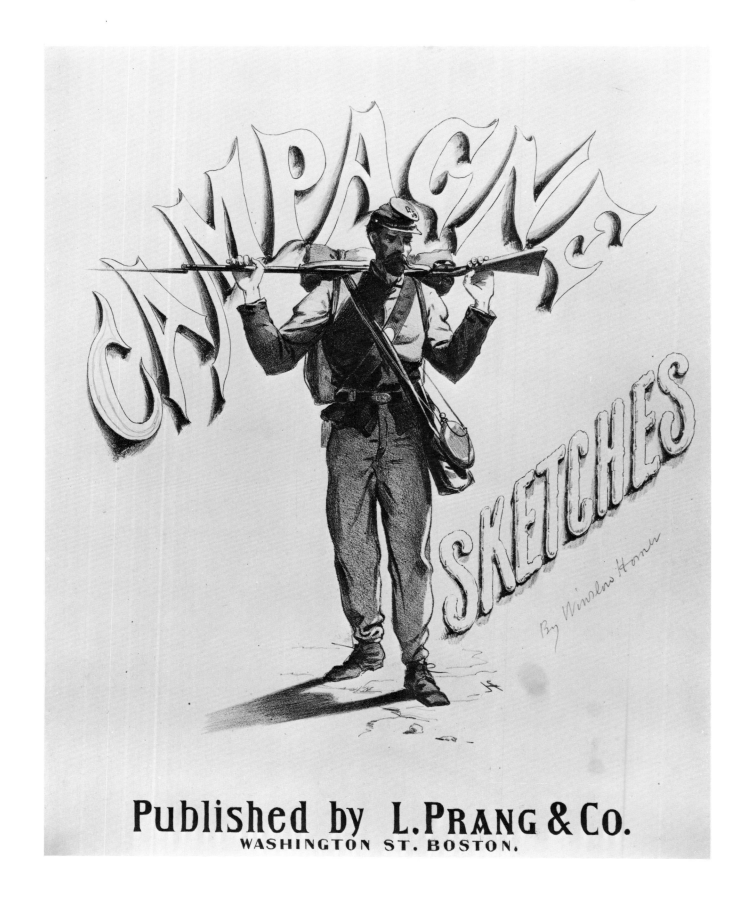

Before the first battle of Bull Run, July 21, 1861, the mood of the North was one of cocksure confidence. According to Walt Whitman:

Nine-tenths of the people of the free States look'd upon the rebellion, as started in South Carolina, from a feeling one-half of contempt, and the other half composed of anger and incredulity. It was not thought it would be join'd in by Virginia, North Carolina, or Georgia. A great and cautious national official predicted that it would blow over "in sixty days," and folks generally believ'd the prediction.[17]

But the war quickly presented a different visage, which we can see reflected in Homer's *Campaign Sketches*. On the title page of this collection of lithographs (the word "campaign" is misspelled on the first proof sheet), a war-weary soldier is shown holding his musket in a natural but nonmilitary manner.

It was a terrible shock to Northern expectations when, after the first defeat at Bull Run, the remnants of the defeated Union forces streamed back into Washington in disarray. Whitman described their plight:

During the forenoon Washington gets all over motley with these defeated soldiers—queer-looking objects, strange eyes and faces, drench'd (the steady rain drizzles on all day) and fearfully worn, hungry, haggard, blister'd in the feet. . . . Amid the deep excitement, crowds and motion, and desperate eagerness, it seems strange to see many, very many, of the soldiers sleeping—in the midst of all, sleeping sound. They drop anywhere, on the steps of houses, up close by the basements or fences, on the sidewalk, aside on some vacant lot, and deeply sleep. A poor seventeen or eighteen year old boy lies there, on the stoop of a grand house; he sleeps so calmly, so profoundly. Some clutch their muskets firmly even in sleep.[18]

44

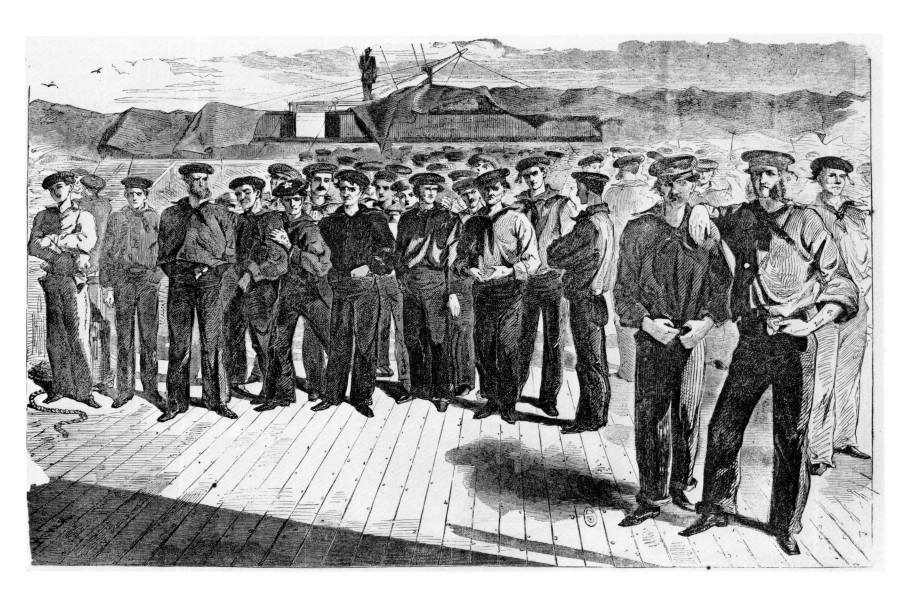

20. *Crew of the United States Steam-Sloop "Colorado," Shipped at Boston, June, 1861.*
Published in *Harper's Weekly*, July 13, 1861. Wood engraving, 9 1/4 x 13 3/4".
Prints Division, The New York Public Library. Astor, Lenox and Tilden Foundations

In the summer of 1861, *Harper's Weekly* published Homer's illustration of Union seamen with the following commentary:

> The reader will find a truthful picture of the crew of the United States steam-frigate *Colorado*, which has lately sailed from Boston to join the blockading fleet. The men were all recruited and shipped at Boston, and we understand that an unusual proportion of them are Americans. Their physique goes to show that the race has not degenerated in that part of the country, and that when occasion offers they will do full justice to the reputation which our gallant tars have won in many a fight and on many a sea.[19]

However gallant the individual "tars" were, they and the vessels they manned were small in number compared to the 3,550 miles of coastline to be blockaded. It was a blockade on paper only for the first few months after April 19, 1861, but by the beginning of August four blockading squadrons were stationed off the eight commercially vital Confederate ports. Silas Horton Stringham was commander of the Atlantic blockade fleet, and in August his squadron took the forts at the entrance to Hatteras Inlet.

It was another year before the Confederacy had naval vessels that could challenge the blockading squadrons. What the Southern harbors did have were first-rate fortifications, which they had inherited from the days of union.

The most important Northern victory

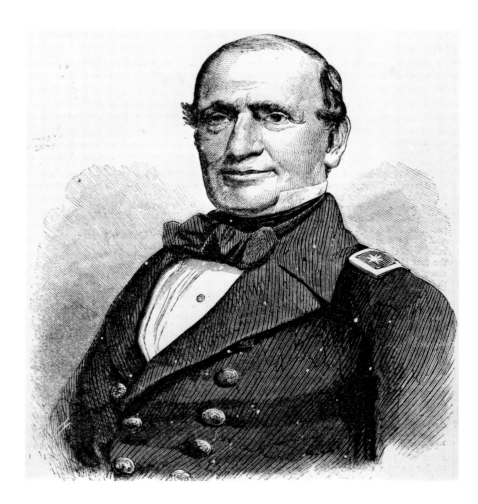

21. *Flag-Officer Stringham.* Published in *Harper's Weekly*, September 14, 1861. Wood engraving, 4 7/8 x 4 3/8″. The Metropolitan Museum of Art, New York City. Harris Brisbane Dick Fund, 1929

in 1861 was a naval one: the capture of the islands opposite Port Royal, South Carolina, which made possible the establishment of bases off the Confederate coast. Before the war was over, the Union navy grew from sixty obsolete sailing vessels and twenty-four steamers to a force of seven hundred ships of all kinds, manned by more than fifty thousand seamen.[20]

22. *Filling Cartridges at the United States Arsenal, at Watertown, Massachusetts.* Published in *Harper's Weekly*, July 20, 1861. Wood engraving, 10 7/8 x 9 1/4″. The Metropolitan Museum of Art, New York City. Harris Brisbane Dick Fund, 1929. Detail opposite

46

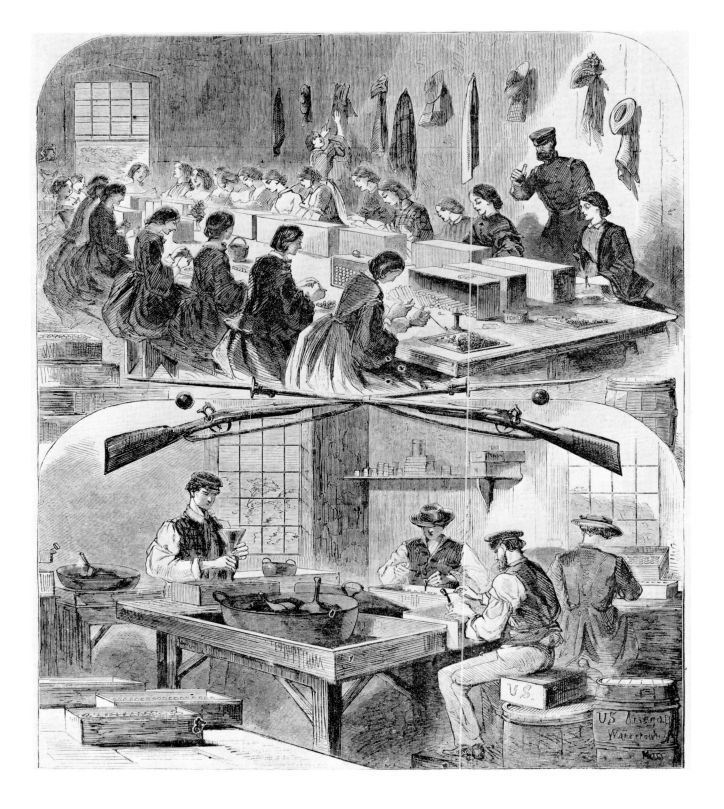

Harper's *Weekly* had this to say about the background of *Filling Cartridges at the United States Arsenal, at Watertown, Massachusetts:*

At this establishment some 300 operatives are kept constantly at work making war material. The powder (of which the best is used, a large quantity which came back from the Mexican War being thrown aside for fear it may not be good) is inserted in the cartridge by men, as shown in the lower picture. The bullet is inserted by girls, as shown in the picture above. At least seventy girls and women are kept constantly employed at Watertown in this avocation. The amount of cartridges turned out daily at this factory alone is enormous; and it is evident that, in the course of a few weeks, there will be no lack of this material of war, at all events.[21]

The optimism of *Harper's Weekly* on this count was not misplaced. Throughout the war the North had the logistical advantage in clothing, shoes, powder, bullets, and other war supplies.

47

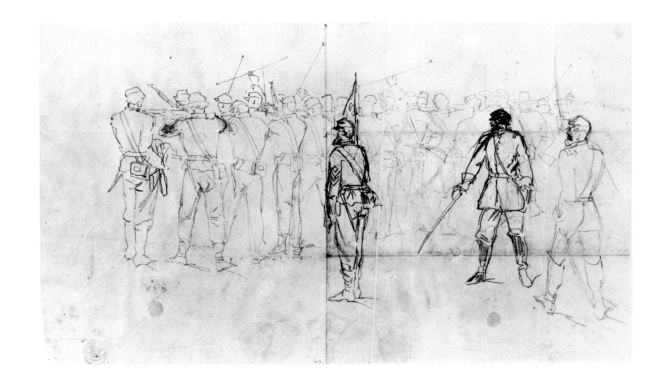

right: 23. *Infantry Rifle Drill.*
1862. Pencil, 8 7/8 x 14 3/4″.
Cooper-Hewitt Museum of Decorative
Arts and Design, Smithsonian
Institution, New York City

below: 24. *Soldiers with Bayonets
Fixed, Escorting Civilians.* 1862.
Pencil, 8 x 3 1/4″. Cooper-Hewitt
Museum of Decorative Arts and
Design, Smithsonian Institution,
New York City

48

Winslow Homer made his first trip to the front in October, 1861. Four months earlier the raw recruits of the Army of the Potomac had suffered disaster at Bull Run (Manassas) in the first Union attempt to drive into Virginia and capture the Confederate capital, Richmond, the governmental, martial, and economic hub of the South and the key to the military planning of both sides.

Homer came to observe at the time President Lincoln had just appointed General George B. McClellan as commander of the demoralized army. To modern eyes McClellan is the most controversial Northern general of the war. Though contemporaries and later historians are divided in their

judgments of McClellan's decisiveness in combat, even his critics admit that he had no equal at organizing and training troops. It has been said that no man could better prepare an army and lead it to the Rubicon—but somebody else would have to take it over. Be that as it may, order and discipline were exactly what were needed at this time. It was not an army McClellan found to command; it was a mere collection of regiments cowering on the banks of the Potomac.[22]

Train he could and train he would. McClellan drilled a hundred thousand men into the largest and most efficient fighting machine the continent had ever seen. This is what Homer drew in sketch after sketch.

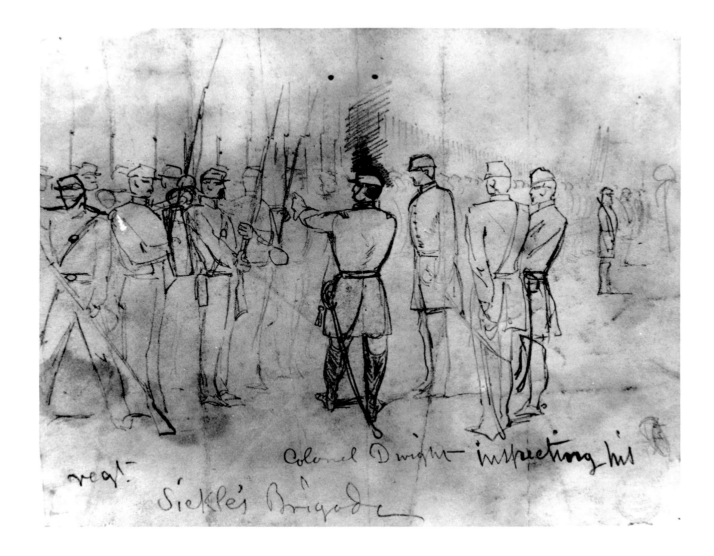

Colonel Dwight inspecting his

regt.

Sickle's Brigade

Looking over Homer's pencil sketches of drilling soldiers, such as *Colonel Dwight Inspecting His Regt. Sickle's Brigade,* one cannot escape the impression that the figures were "blocked in," with square shoulders giving them the appearance of military puppets. Perhaps that was the way they appeared to Homer. He showed a keen eye for stance, and his hand could reproduce—either with sympathy or with satire—what he saw. It is interesting to note that in the figure of the soldier at far right in the foreground group of officers, Homer captured a military bearing which is not stiff.

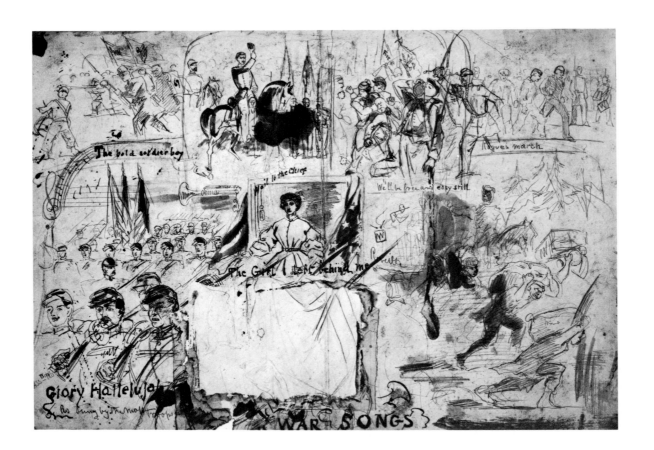

26. *War Songs*. 1861. Pencil, 14 x 20″.
Library of Congress, Washington, D.C.

It was the first year of the war. The favorite melody "Glory, Hallelujah" did not yet have its great verses beginning, "Mine eyes have seen the glory of the coming of the Lord." Late in the year, on November 21, Mrs. Julia Ward Howe attended a review of troops near Washington. Hearing the marching soldiers singing the song, her escort, the Reverend James Freeman Clarke, is said to have asked Mrs. Howe why she did not compose more fitting words to the stirring music. That night in her room at Willard's Hotel she wrote the most stately and inspiring of all Union songs, "The Battle Hymn of the Republic."

Homer's vignettes exhale exuberance: *Glory, Hallelujah; Hail to the Chief; The Bold Soldier Boy; We'll Be Free and Easy Still; Rogues March; Reveille; The Girl I Left Behind Me;* and *Dixie*. The songs characteristic of the final years of the war, with their expression of an overwhelming feeling of the separation of men from women, were yet to come.[23]

In *We'll Be Free and Easy Still*, Homer portrays the true attitude of some Civil War soldiers. The freehand sketch of this scene emphasizes the liberties taken by these men, who are drinking

(continued)

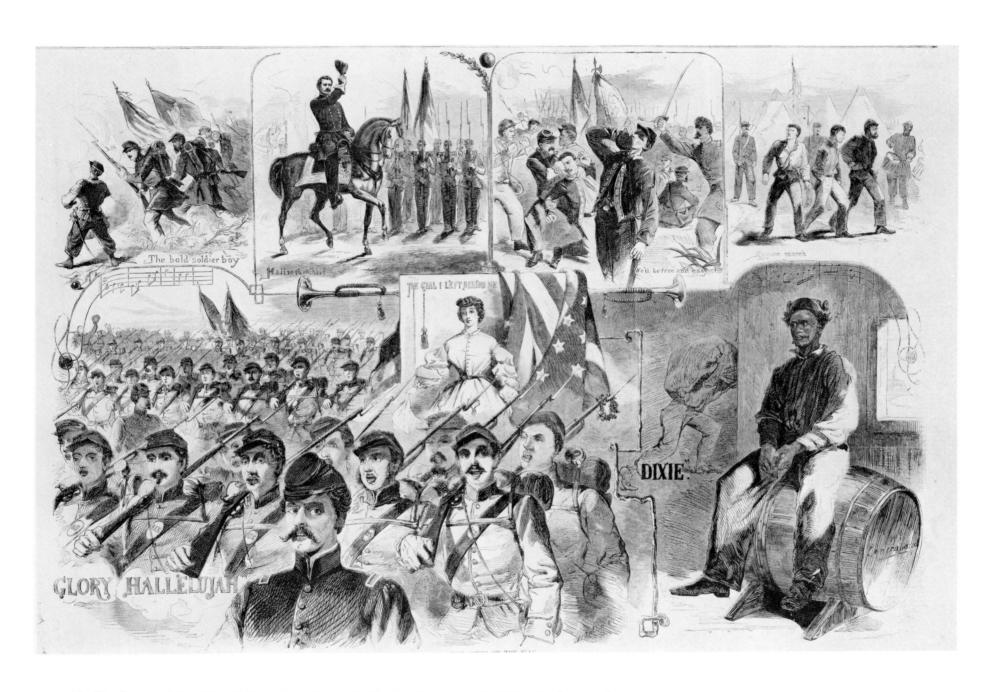

27. *The Songs of the War*. Published in *Harper's Weekly*, November 23, 1861. Wood engraving, 14 x 20″. The Metropolitan Museum of Art, New York City. Harris Brisbane Dick Fund, 1929

and brawling in camp. Even when this cursory drawing was translated into the firmer outlines of a wood engraving, the feeling of license remained. The eminent Civil War historian Bruce Catton holds that this free-and-easy quality was the distinguishing characteristic of the volunteer armies.[24]

Of special interest is the illustration for the song "Dixie" in which a Negro sits on a barrel marked "Contraband." The allusion was clear to Homer's contemporaries. Six months earlier, at the very beginning of the war, an incident had occurred which was heartening to the black men and women striving for their freedom during the Civil War.[25]

Three Negro men, under Virginia law the slaves of Colonel Charles Mallory, a Confederate army commander, escaped to Fortress Monroe and to the colonel's Northern counterpart, Major General Benjamin F. Butler. Their daring was matched by Butler's wits. When a Confederate major came for his colonel's slaves ... but let Butler tell the story:

[Major Cary of the Confederate army] desired to know if I did not feel myself bound by my constitutional obligations to deliver up fugitives under the Fugitive Slave Act. To this I replied that the Fugitive Slave Act did not affect a foreign country, which Virginia claimed to be, and that she must reckon it one of the infelicities of her position that in so far at least, she was taken at her word; that in Maryland, a loyal State, a fugitive from service had been returned, and that even now, although so much pressed by my necessities for the use of these men of Col. Mallory's, yet if their master would come to the Fortress and take the oath of allegiance to the constitution of the United States I would deliver the men up to him, and endeavor to hire their services of him, if he desired to part with them.[26]

It was in this interview that General Butler applied the term "contraband" to a Negro slave who escaped to the Union lines during the war.[27] The expression was quickly adopted by the public in general. Butler's superiors in the War Department endorsed his action, and the news went out that slaves had a new route to freedom.[28]

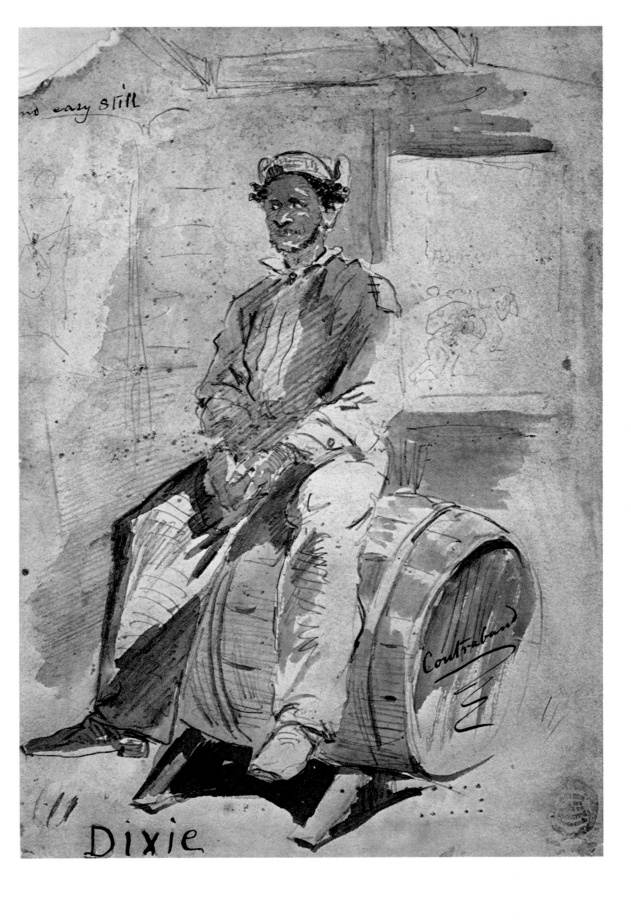

28. *Dixie*. 1861. Pencil and
blue, gray, and pale red wash,
10 x 7″. Cooper-Hewitt Museum
of Decorative Arts and Design,
Smithsonian Institution,
New York City

53

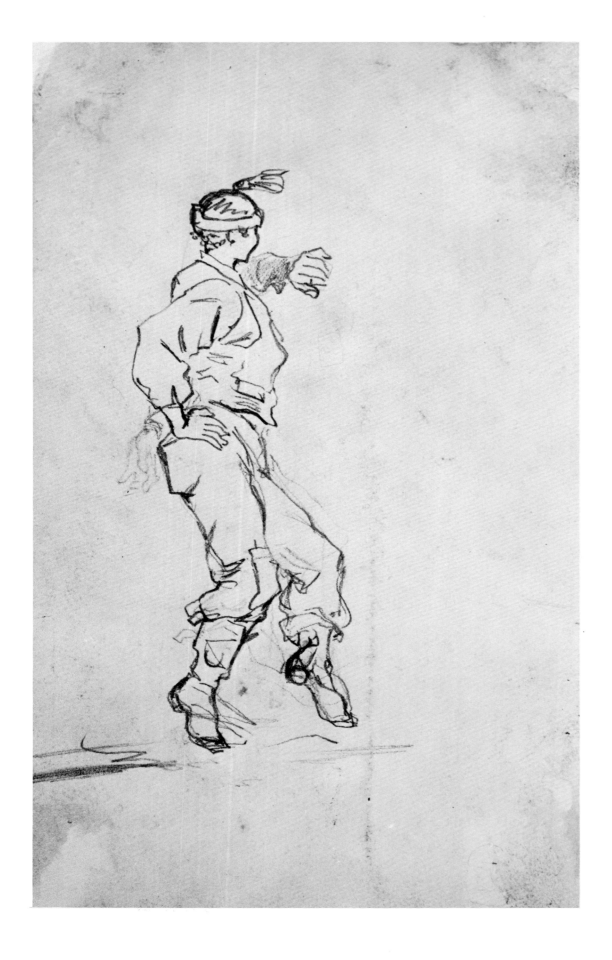

29. *Soldier Dancing.* c. 1861.
Pencil, 9 1/2 x 6 1/4″. Cooper-Hewitt
Museum of Decorative Arts and Design,
Smithsonian Institution, New York City

At night, after the day's drills were done, the men would gather together around the campfire. Such a scene is shown in *A Bivouac Fire on the Potomac*.

A glorious dancing figure, filled with life, is the central element in a composition of light pitted against dark. Defining the circle of darkness around the campfire are the sentinels, their rifles tipped with bayonets. Grotesque shadows play over the stretched canvas tents. Silhouetted by the fire, the dancer balances, twirls, and stamps out his rhythmic steps to the accompaniment of a fiddle. Smoking, resting, or playing cards, the men watch the dance, keeping up their spirits on a lonely night.

Homer's original drawings have a spontaneity that captures with economy of line the person, the place, and the time, a spontaneity that the reworked scenes sometimes lose.

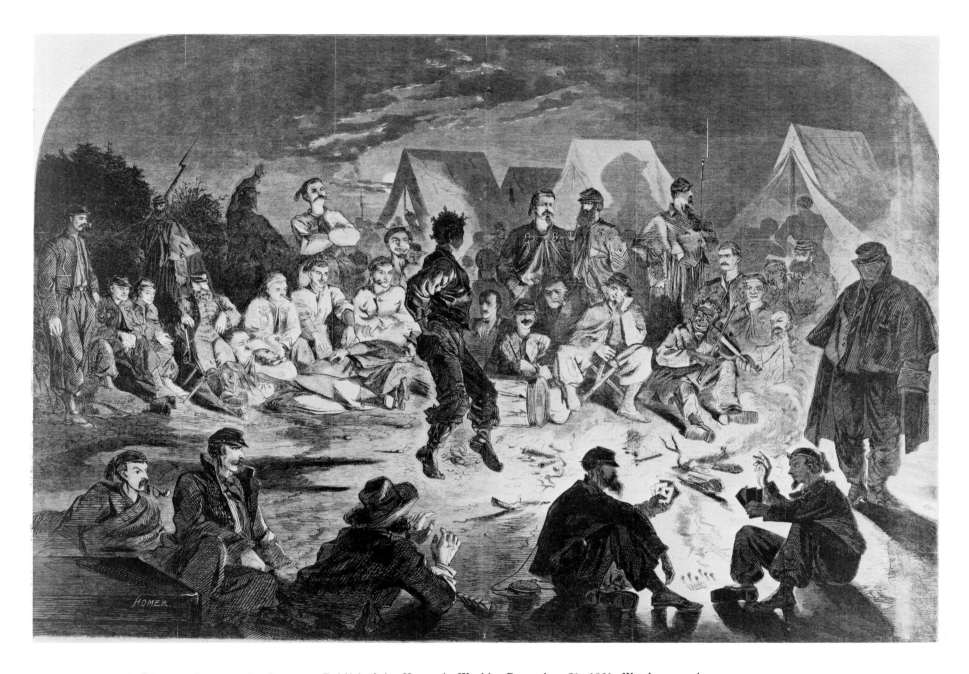

30. *A Bivouac Fire on the Potomac.* Published in *Harper's Weekly*, December 21, 1861. Wood engraving, 13 ¾ x 20 ¼″. The Metropolitan Museum of Art, New York City. Harris Brisbane Dick Fund, 1929

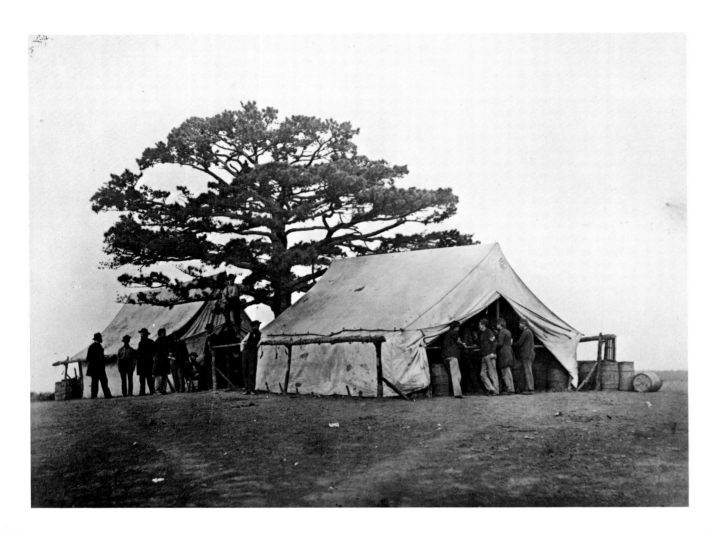

31. Anonymous. *Sutler's
Tent at Army of the Potomac
Headquarters, Bealeton,
Virginia.* August, 1863.
Photograph. Library of Congress,
Washington, D.C. Mathew B.
Brady Collection

32. *Christmas Boxes in Camp—
Christmas, 1861.* Published in
Harper's Weekly, January 4, 1862.
Wood engraving, 10 7/8 x 9 1/8″.
The Metropolitan Museum of Art,
New York City. Harris Brisbane
Dick Fund, 1929

During the holiday season, tracts
and books were laid aside for the
triumphant reception of warm socks,
mittens, and home-cooked delicacies.
Nothing is so bitter-sweet as
Thanksgiving away from home or
Christmas away from loved ones. As
a major illustrator, Homer acted as a
sort of intermediary between the folks
at home and their men at the front.
He reminded those left to wait of
the rough good humor shared by men
enduring the same hardships and
welcoming the same small joys.

The sutlers were civilians who followed
the troops, selling small items which
the army did not supply. With the
arrival of packages from home, as
in Homer's illustration of Christmas
in camp, 1861, there was no need to
visit the sutler's tent and pay
exorbitant prices for cakes and small
pies, canned fruit, tobacco, and cider
(or illegal whiskey).[29]

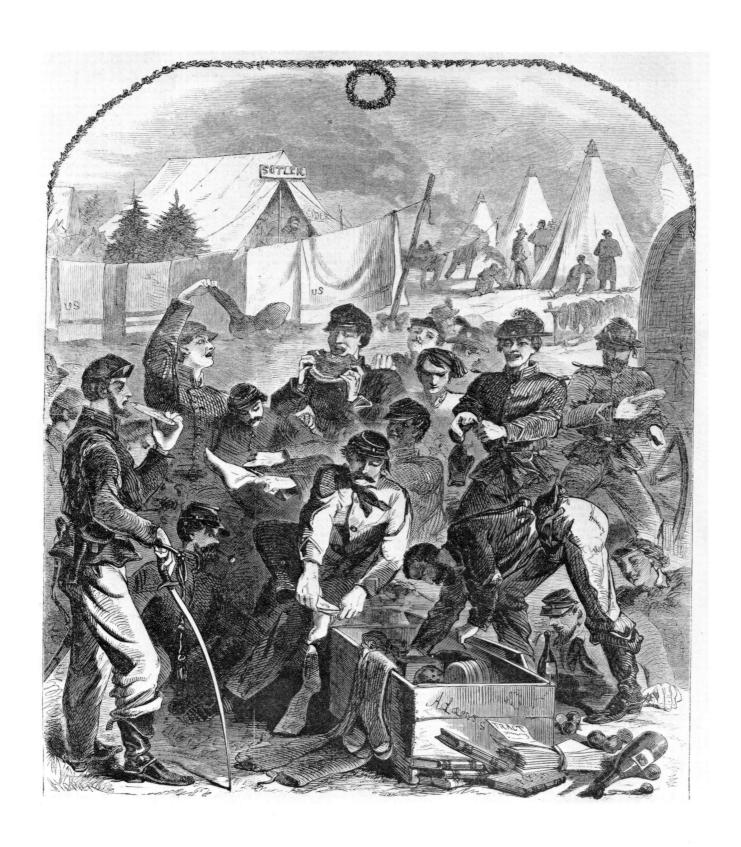

33. *General McClellan's Sixth Pennsylvania Cavalry Regiment Ready to Embark*
at Alexandria for Old Point Comfort. 1862. Pencil and gray wash, 8 5/8 x 15 7/8".
Cooper-Hewitt Museum of Decorative Arts and Design, Smithsonian Institution, New York City

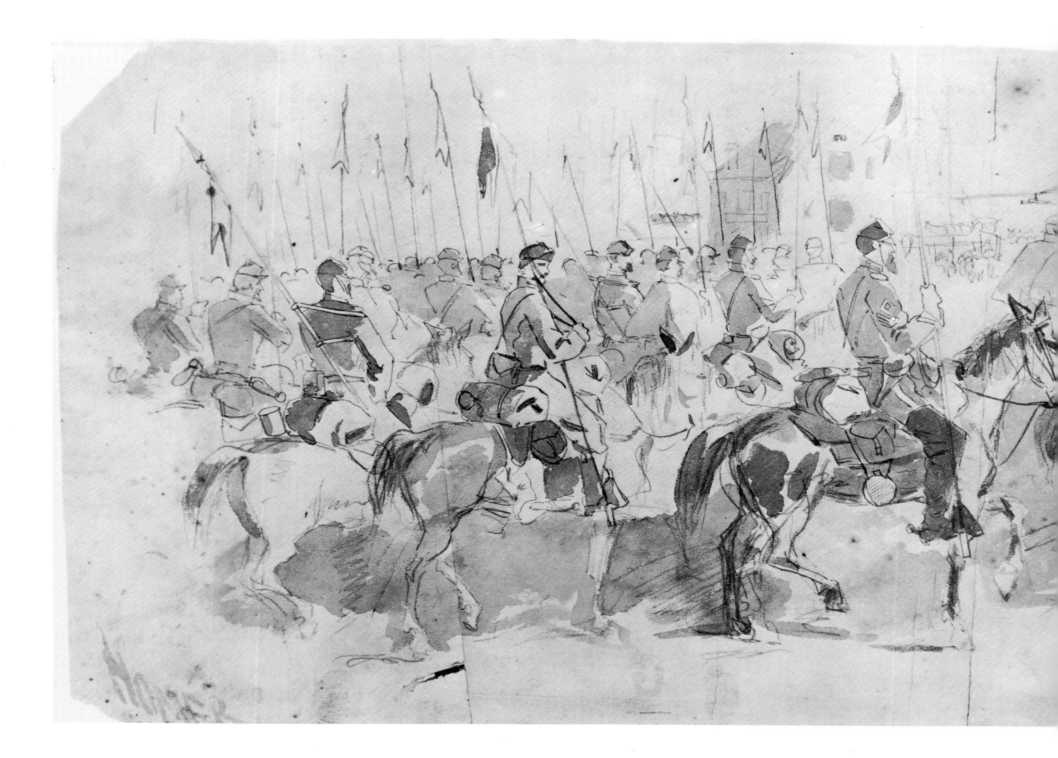

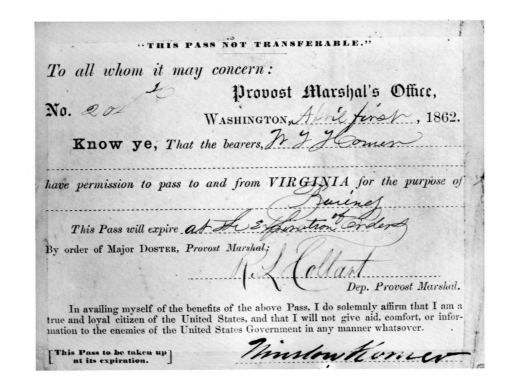

34. Homer's Civil War pass. April 1, 1862. Bowdoin College Museum of Art, Brunswick, Maine. Homer Collection

By the time the dogwood trees of Virginia forests were ready to bloom in the spring of 1862, McClellan's army was ready to prove its mettle: the goal was Richmond. The scene was set for the Peninsular campaign. This entailed the largest amphibious operation heretofore attempted in the Western world. Taking advantage of the Union control of inland water systems to transport his army, McClellan assembled over four hundred steam vessels, brigs, schooners, sloops, and barges on the Potomac River.[30]

Homer made his second trip to the front at this time and was with the troops on April 4, 1862, when Major General George B. McClellan and his Union army set out to attack the Confederate capital by way of the York Peninsula. With crisp use of black wash and highlights, Homer pictured the embarkation of General McClellan's Sixth Pennsylvania Cavalry Regiment of Lancers.

Homer stayed with McClellan's army during the first phase of the campaign in April and early May, 1862. The Army of the Potomac—well-armed, trained to a keen fighting edge, and one hundred thousand strong—was the most formidable military force yet seen on American soil. The men were eager for action, their devotion to their commander complete. Lincoln urged McClellan to make haste and strike a decisive blow, but the general's cautious attitude allowed the Confederate forces time for a hasty construction of entrenchments and field works across the peninsula from Yorktown. The Army of the Potomac's advance was held up for the entire month of April. Homer was there to watch McClellan besiege Yorktown.

59

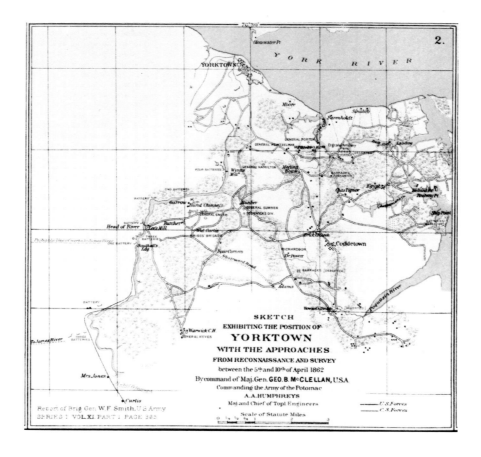

35, 36 (below). Maps of Yorktown, from *Atlas to Accompany the Official Records of the Union and Confederate Armies*, published under the direction of the Secretaries of War (Washington, D.C.: Government Printing Office, 1891-95).

McClellan's forces besieged Yorktown, occupying numerous positions deserted when the Confederate forces withdrew to the heavily defended city. According to the note accompanying Fig. 36, "The Rebel Line extended across the Peninsula. Its Left, the Works of Yorktown, consisted of a formidable field work ... with Water Batteries which, joined to those of Gloucester Pt., closed York River ... the right bank [of the Warwick River] was strongly held by lines of trenches with occasional redoubts and batteries. ..." General Porter's position, amid peach orchards on Wormley's Creek, can be seen at bottom of Fig. 36.

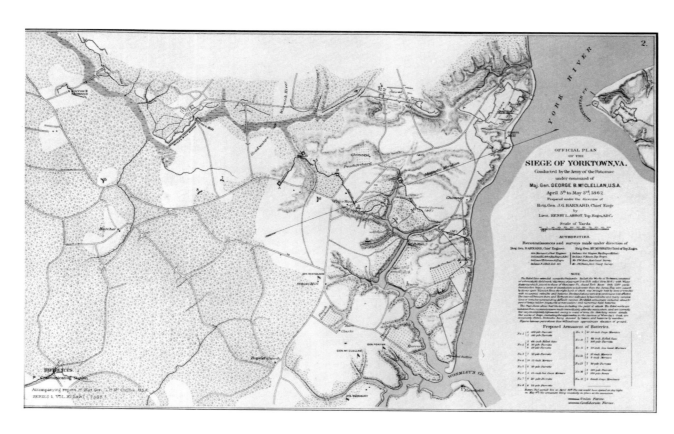

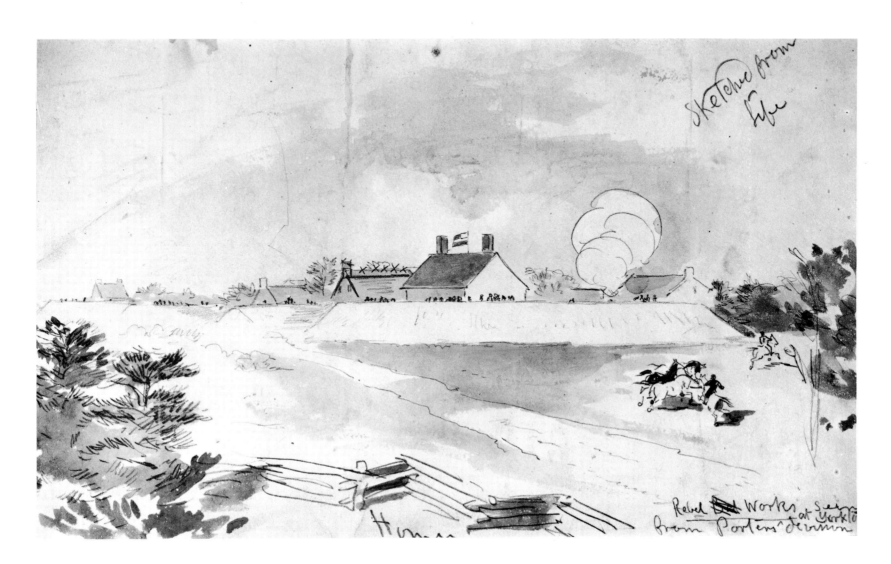

37. *Rebel Works Seen at Yorktown from Porter's Division.* 1862. Pencil and wash, 8 1/8 x 13 1/4". Museum of Fine Arts, Boston. M. and M. Karolik Collection

Harper's *Weekly* explained that the wood engraving *Our Army Before Yorktown, Virginia* (Fig. 39) was from sketches by Mr. A. R. Waud and Mr. W. Homer. Prior to this compilation of Homer's Civil War work, the critics have found it impossible to determine which of the seven unsigned blocks were by Homer.[31]

Now it becomes evident that *Rebel Works Seen at Yorktown from Porter's Division* and *Reconnaissance in Force by Genl. Gorman* are from Homer sketches (Figs. 37 and 38). It is also possible to state with confidence that the scene titled *Religious services in Camp of 61st N.Y. Volunteers* was drawn by Homer because he was attached to the staff of Francis C. Barlow, Commander of the Sixty-first Regiment of New York Volunteers.[32]

(continued)

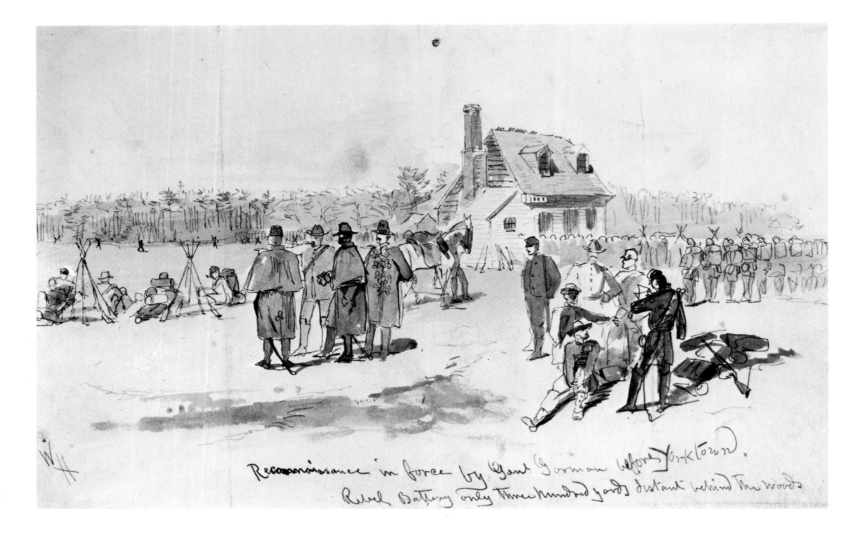

Reconnaissance in force by Genl Gorman before Yorktown.
Rebel Battery only three hundred yards distant behind the woods

38. *Reconnaissance in Force*
by Genl. Gorman Before Yorktown.
Rebel Battery Only Three Hundred
Yards Distant Behind the Woods.
1862. Pencil and wash, 8 1/4 x 13 1/4″.
Museum of Fine Arts, Boston.
M. and M. Karolik Collection

It has been implied that Winslow Homer spent most of his time safely behind the front lines, at camp. One drawing alone, never before published, would be enough to dispel this myth. The sketch of rebel works at Yorktown (Fig. 37) is marked boldly in Homer's hand: "Sketched from Life."

Homer must have been witness to many engagements similar to the one reported back to headquarters by Barlow: "As we approached the woods on the other side of the field the enemy asked from within what regiment we were. My men answering, 'Sixty-first New York,' the enemy shouted, 'Throw down your arms, or you are all dead men!' We at once opened fire upon them."[33]

39. Winslow Homer and A. R. Waud. *Our Army Before Yorktown, Virginia*. Published in *Harper's Weekly*, May 3, 1862.
Wood engraving, 13 3/4 x 20 3/4". The Metropolitan Museum of Art, New York City. Harris Brisbane Dick Fund, 1929

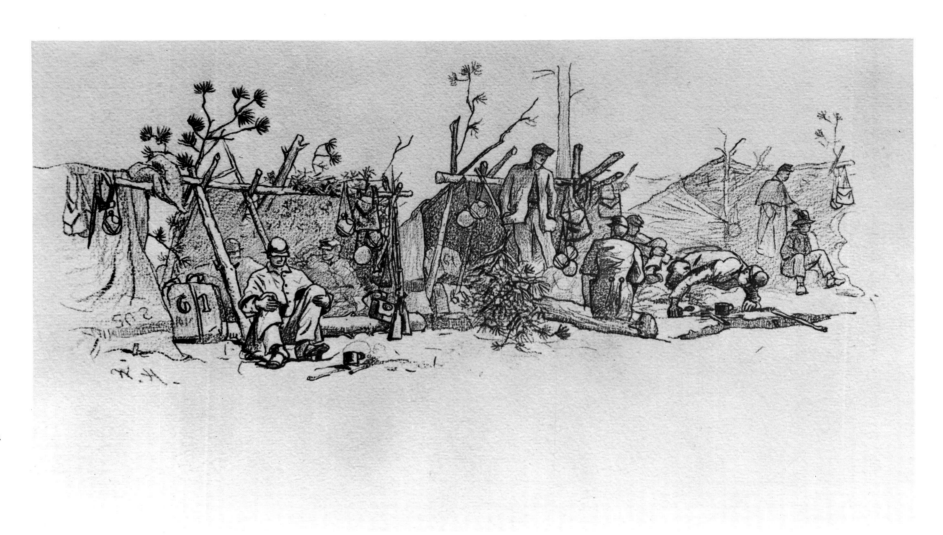

40. *Sketch/In Front of Yorktown, 1862.* 1862. Ink and crayon, 8 x 14″.
Addison Gallery of American Art, Phillips Academy, Andover, Massachusetts

41. *Men Looking over Earthworks.*
1862. Pen and brown ink on gray paper,
4 3/8 x 8 1/2". Cooper-Hewitt Museum
of Decorative Arts and Design,
Smithsonian Institution, New York City

42. *The Last Goose at
Yorktown.* c. 1863. Oil on
canvas, 14 1/4 x 18 1/4". Kennedy
Galleries, Inc., New York City

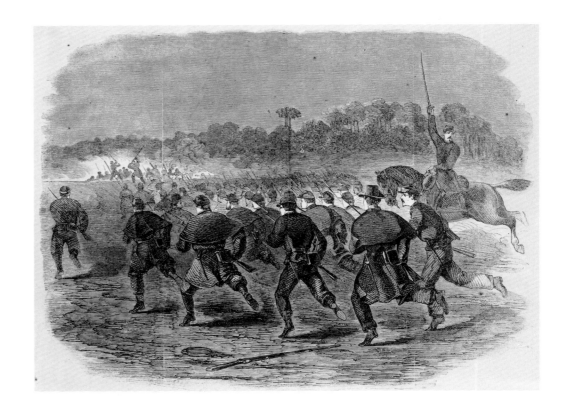

right: 43. *Charge of the First Massachusetts Regiment on a Rebel Rifle Pit near Yorktown.* Published in *Harper's Weekly,* May 17, 1862. Wood engraving, 6 ⁷/8 x 9 ¹/8″. The Metropolitan Museum of Art, New York City. Harris Brisbane Dick Fund, 1929

below right: 44. *Rebels Outside Their Works at Yorktown Reconnoitring* [sic] *with Dark Lanterns.* Published in *Harper's Weekly,* May 17, 1862. Wood engraving, 10 ⁷/8 x 9 ¹/4″. The Metropolitan Museum of Art, New York City. Harris Brisbane Dick Fund, 1929

It would be fascinating to have the Peninsular campaign pictorially documented in wood engravings by Homer, but we are denied this. The next four of his illustrations to appear in *Harper's Weekly* are in actuality as captioned: "Sketched by Mr. W. Homer" or "From sketches by Mr. W. Homer." The style, or rather lack of it, indicates that the sketches Homer sent back were redrawn on the block by another artist.

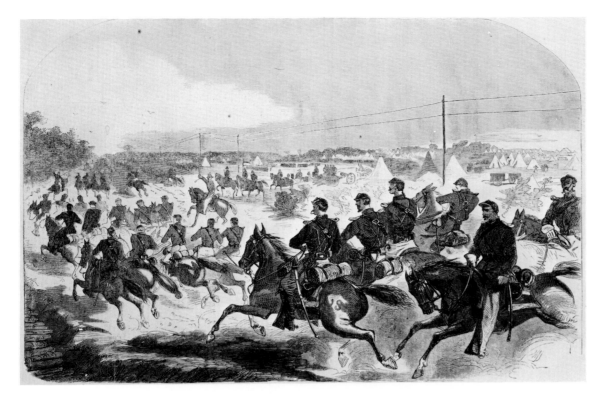

45. *The Union Cavalry and Artillery Starting in Pursuit of the Rebels up the Yorktown Turnpike.* Published in *Harper's Weekly*, May 17, 1862. Wood engraving, 9 1/4 x 13 3/4". The Metropolitan Museum of Art, New York City. Harris Brisbane Dick Fund, 1929

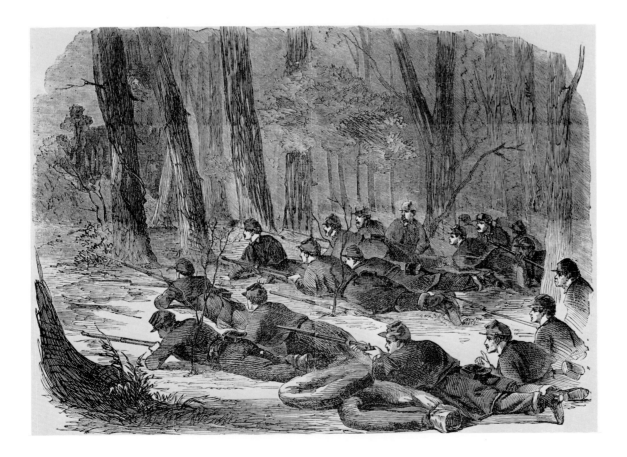

46. *The Army of the Potomac—Our Outlying Picket in the Woods.* Published in *Harper's Weekly*, June 7, 1862. Wood engraving, 6 7/8 x 9 1/4". The Metropolitan Museum of Art, New York City. Harris Brisbane Dick Fund, 1929

47. *Soldiers Seated in a Group.* 1862. Watercolor and pencil,
3 1/2 x 4 7/8". Cooper-Hewitt Museum of Decorative Arts and Design,
Smithsonian Institution, New York City

48. *In Front of Yorktown.* 1862. Oil on canvas, 13 1/2 x 20". Yale University
Art Gallery, New Haven, Connecticut. Gift of Samuel R. Betts, Yale B.A. 1875

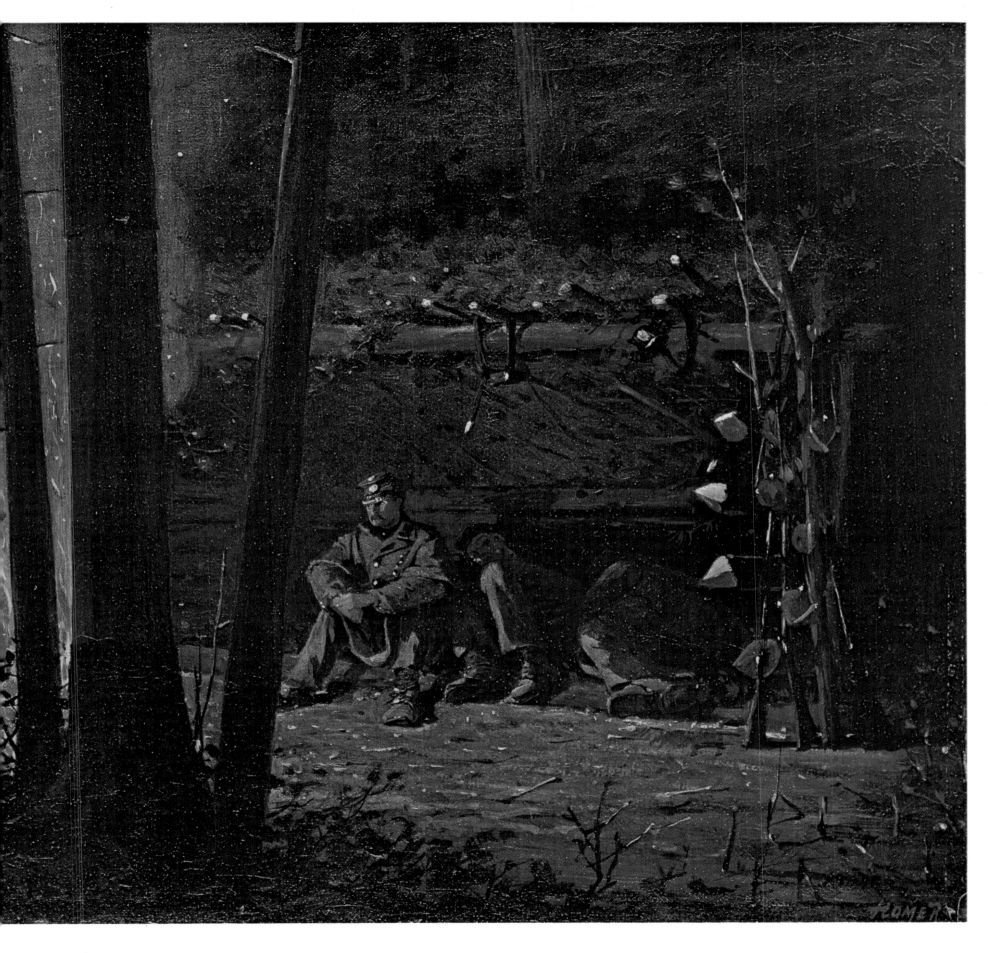

49. *Feeling the Enemy.* c. 1887-88. Pencil and ink, 14 1/4 x 19 1/4″. The Art Museum, Princeton University, New Jersey

Although Homer left the fighting before the end of McClellan's Peninsular campaign, he drew scores of pencil and charcoal sketches of soldiers reconnoitering, skirmishing, or just loafing in camp. By the beginning of June he was back in New York with sketchbooks filled with rich material that he was to mine for years to come.

50. *Study of Soldiers*. 1862. Pencil,
4 3/4 x 3 1/4". Cooper-Hewitt Museum of
Decorative Arts and Design, Smithsonian
Institution, New York City

51. *Study of a Soldier*. 1862. Pencil,
4 3/4 x 3 1/2". Cooper-Hewitt Museum of
Decorative Arts and Design, Smithsonian
Institution, New York City

52. *Soldier Loading a Rifle.* c. 1863.
Black chalk with corrections in white
gouache on green-gray paper, 16 3/4 x 13".
Cooper-Hewitt Museum of Decorative Arts
and Design, Smithsonian Institution,
New York City ▶

One of the finest of Homer's sketches is *Soldier Loading a Rifle.* Each stroke captures the texture, the shadow, the reality of this figure.

The Union army had the advantage in equipment, but in the War Department the bureaucracy of elderly officers led by Colonel James Ripley (popularly known as Ripley Van Winkle) prevented the adoption of the breech-loading rifle until almost war's end. Thus the Civil War was largely a war of muzzle-loaders.

The muzzle-loading, .58-caliber Springfield rifle was the standard piece of the Union infantry and fired the famous Minié ball, an elongated bullet made of soft lead, about an inch long, pointed at one end and hollowed out at the base.[34]

In little more than a hundred years, we have gone from the single-shot rifle to nuclear weapons. There is undoubtedly a connection between war and the development of technology. The need for mass production of standard items first became apparent in the military sphere, where standard firearms were required. In fact, the first major order received by Maudsley, the developer of machine tools, was from the British Admiralty in 1800.[35]

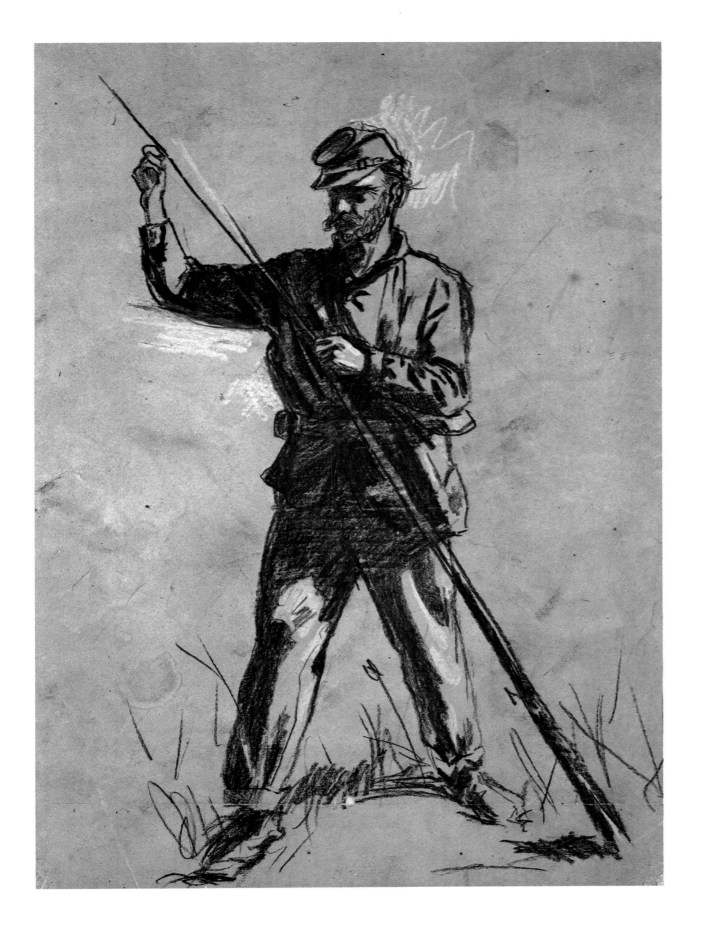

73

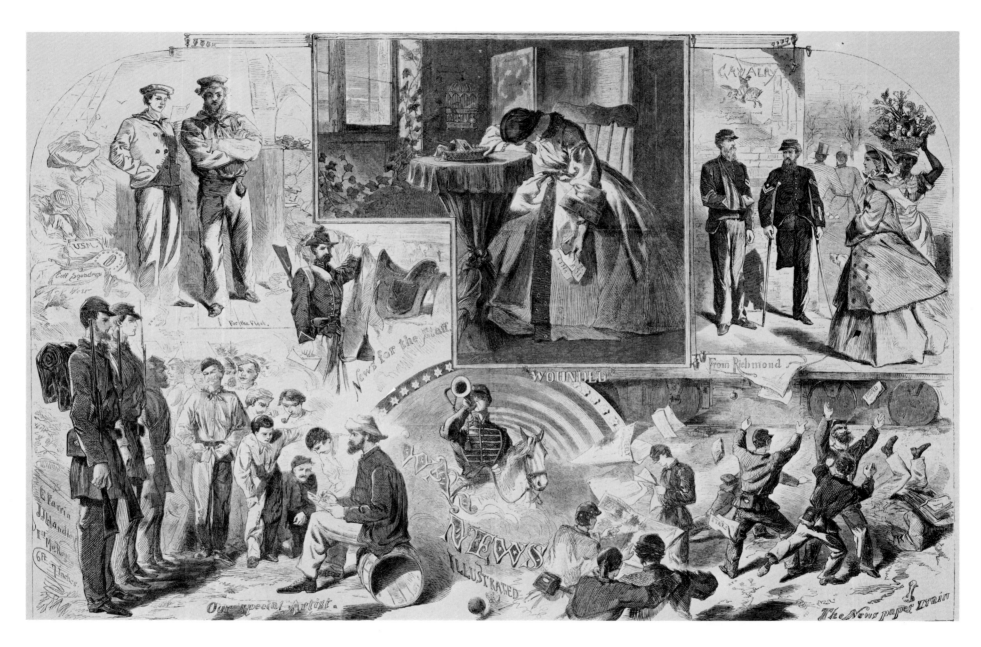

53. *News from the War.* Published in *Harper's Weekly*, June 14, 1862. Wood engraving, 13 1/4 x 20 1/4".
The Metropolitan Museum of Art, New York City. Harris Brisbane Dick Fund, 1929. Detail opposite

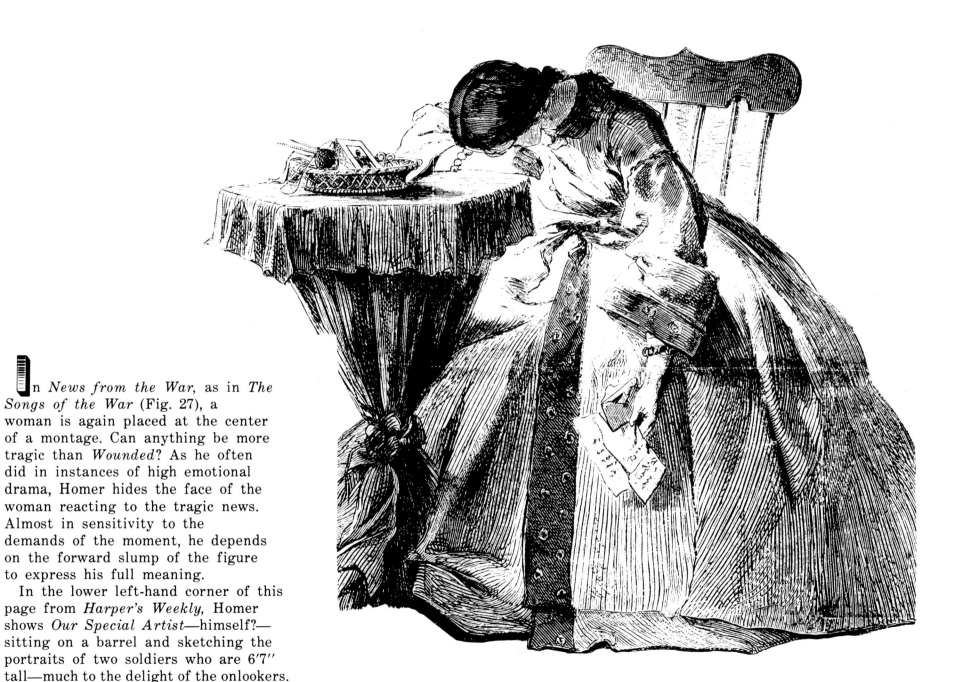

In *News from the War*, as in *The Songs of the War* (Fig. 27), a woman is again placed at the center of a montage. Can anything be more tragic than *Wounded*? As he often did in instances of high emotional drama, Homer hides the face of the woman reacting to the tragic news. Almost in sensitivity to the demands of the moment, he depends on the forward slump of the figure to express his full meaning.

In the lower left-hand corner of this page from *Harper's Weekly*, Homer shows *Our Special Artist*—himself?—sitting on a barrel and sketching the portraits of two soldiers who are 6'7" tall—much to the delight of the onlookers.

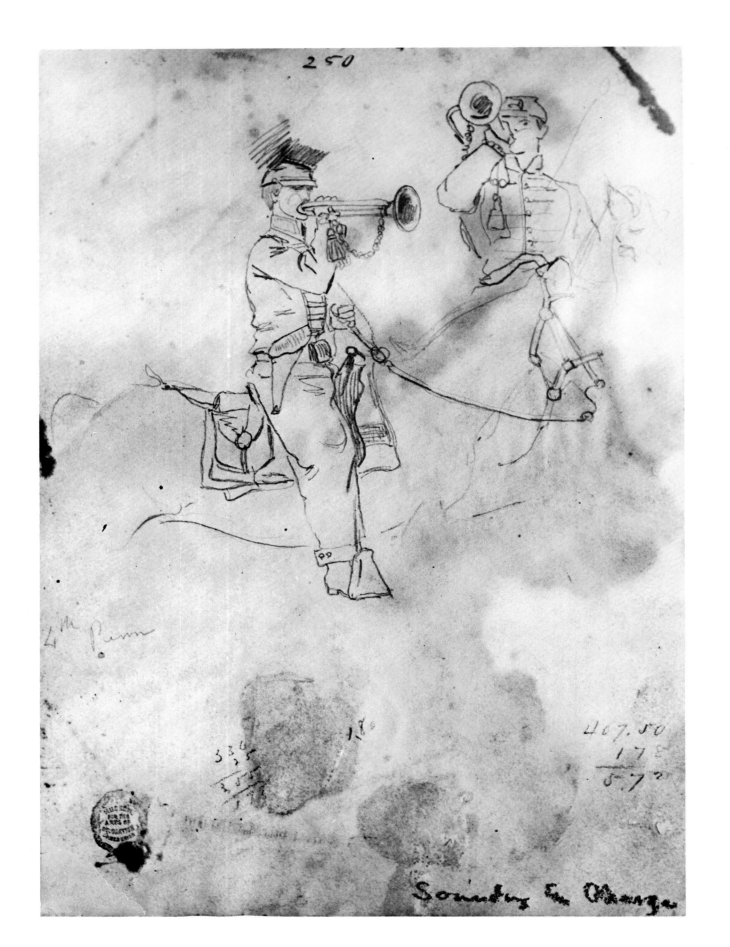

54. *Sounding the Charge.* 1862.
Pencil, 10 x 7″. Cooper-Hewitt
Museum of Decorative Arts and Design,
Smithsonian Institution, New York City

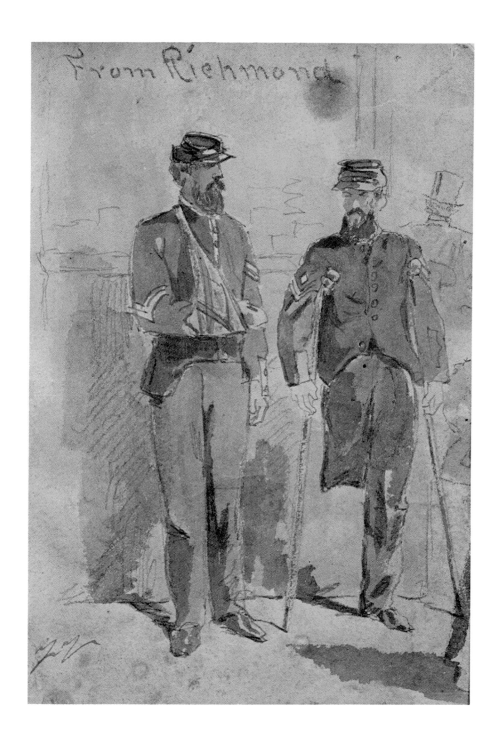

55. *From Richmond*. 1862. Pencil and blue,
gray, red, and brown wash, 6 1/8 x 5 1/8".
Cooper-Hewitt Museum of Decorative Arts
and Design, Smithsonian Institution,
New York City

The dominant and highly romantic dyad of man and horse, the man with his face hidden from view by his upraised arm, might have been inspired by the Book of Job, so well does the graphic artist illustrate the war horse:

Hast thou given the horse his strength?
Hast thou clothed his neck with
 fierceness?
Hast thou made him to leap as a locust?
The glory of his snorting is terrible.
He paweth in the valley, and
 rejoiceth in his strength;
He goeth out to meet the clash of
 arms.[36]

Within this tapestry-like *Cavalry Charge* the action is particularly intense in the lower right-hand corner. A look of fright passes over the face of the fallen soldier, but unknown to him his life is being guarded by a determined comrade on horseback whose protective saber is about to strike the threatening enemy.

As images of war, Homer's *Cavalry Charge* and *A Bayonet Charge* (Fig. 57) concentrate on heroic deeds, gallantry, and courage in the face of death, not on death itself. Excellent propaganda, these two illustrations of all-out warfare celebrate the Union cause—only brave Union soldiers fill the picture frame. The Rebels offer no more than slight resistance to what Homer, back in his New York studio, has portrayed as invincible Northern forces.

78

56. *The War for the Union, 1862—A Cavalry Charge*. Published in *Harper's Weekly*, July 5, 1862. Wood engraving, 13 1/2 x 20 5/8". The Metropolitan Museum of Art, New York City. Harris Brisbane Dick Fund, 1929

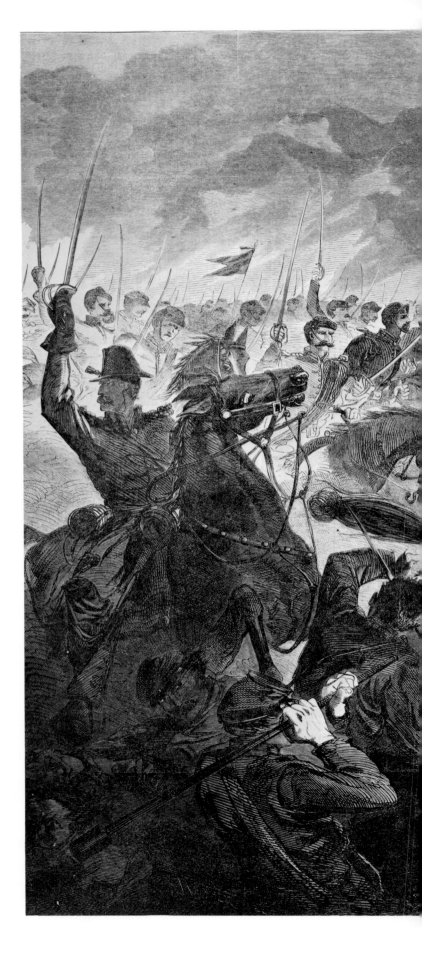

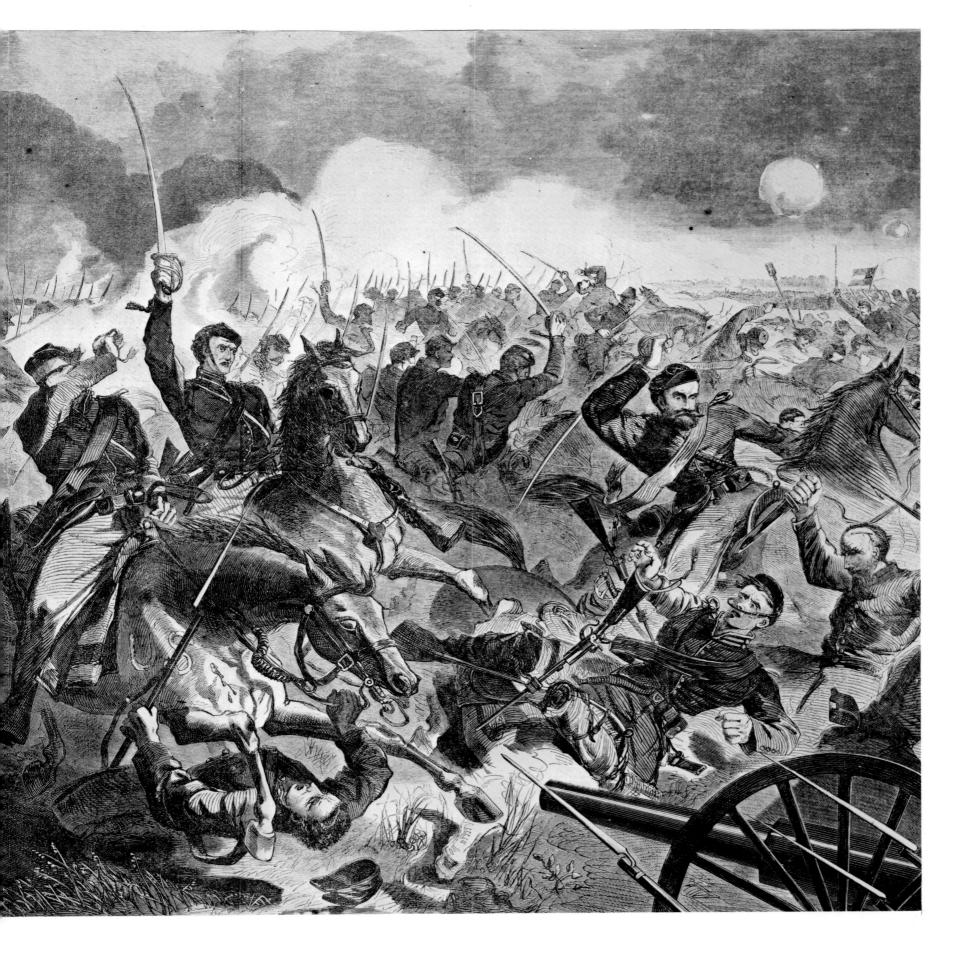

Homer focuses attention on the figure in the center. As if in a bad dream, he doggedly goes about his business. He has not made contact with any of the enemy, but he has readied himself with a certain amount of fear and determination. He is urged on by the officer in the left foreground of the picture, who leads the bayonet charge. And he is watched intently by the soldier to the right. Compare the words of Stephen Crane in *The Red Badge of Courage*, describing a Civil War recruit's emotions under fire: "There was a consciousness always of the presence of his comrades about him. He felt the subtle battle brotherhood more potent even than the cause for which they were fighting. It was a mysterious fraternity born of the smoke and danger of death."[37]

To take exception to the factual accuracy of Homer's mass battle illustrations might seem picayune in the face of the dramatic imagery presented, but a sober analysis of the facts calls for just this. Homer was clearly interested in creating romantic battle scenes, rather than straightforward factual reports of specific historical events. Other evidence tends to support this conclusion. For example, although most infantry rifles were equipped with bayonets, the bayonet was not a lethal weapon. When the opposing soldiers did come to grips, they most often used their rifles as clubs.[38]

Before 1863 the Federal cavalry was no match for that of the enemy. It was recruited from men who had never been on a horse; the training was insufficient and too speedy; many of the horses were unsound and all were overloaded. Though on occasion there were mounted saber charges, for the most part, and especially in the early years of the war, the Federal cavalry used dismounted actions.[39]

The hypothesis that these mass battle scenes were drawn from imagination rather than observation gains credence from the fact that no original drawings or on-the-spot sketches of any of the groupings can be found. It is true that Homer made many eyewitness sketches at the front, the authenticity of which cannot be denied (see following pages). But in the midst of battle, it would be hard to remember where the soldiers were and what they were doing. As if to acknowledge the nature of Homer's images as generalizations, *Harper's Weekly* captioned these illustrations simply *A Cavalry Charge* and *A Bayonet Charge* (Figs. 56 and 57), scenes meant to give a positive impression of the progress of the war, rather than to represent specific battle scenes.

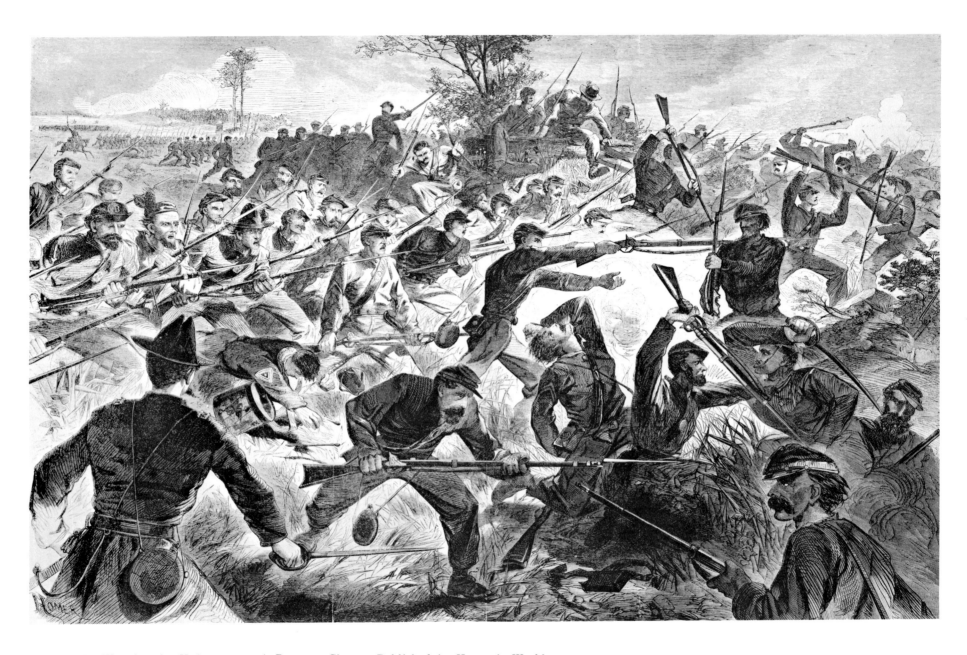

57. *The War for the Union, 1862—A Bayonet Charge.* Published in *Harper's Weekly,*
July 12, 1862. Wood engraving, 13 5/8 x 20 5/8″. The Metropolitan Museum of Art,
New York City. Harris Brisbane Dick Fund, 1929

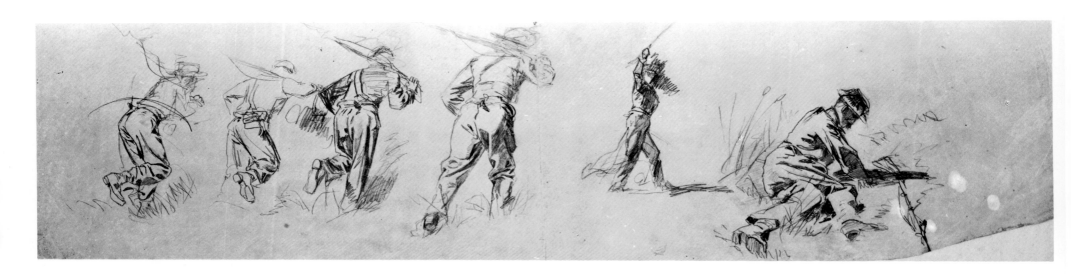

58. *Sketches of Soldiers*. c. 1863. Pencil,
9 3/4 x 36″. Cooper-Hewitt Museum of Decorative Arts and
Design, Smithsonian Institution, New York City

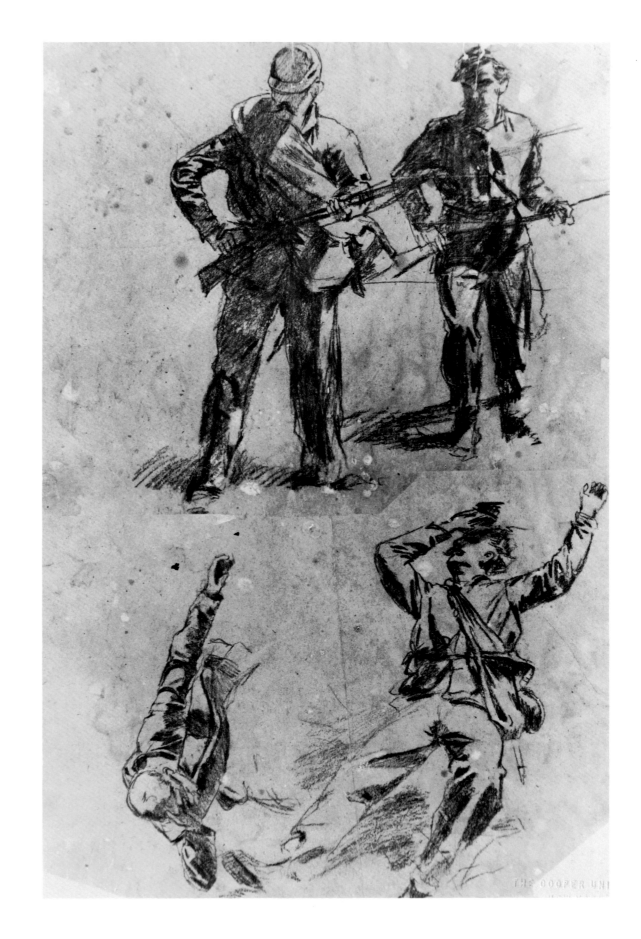

59. *Four Studies of Soldiers*. 1864.
Black and white chalk on brown paper,
24 5/8 x 16″. Cooper-Hewitt Museum of
Decorative Arts and Design, Smithsonian
Institution, New York City

60. *Three Days on the Battlefield*. c. 1864. Black chalk on blue paper, 8 7/8 x 17 3/4". Cooper-Hewitt Museum of Decorative Arts and Design, Smithsonian Institution, New York City

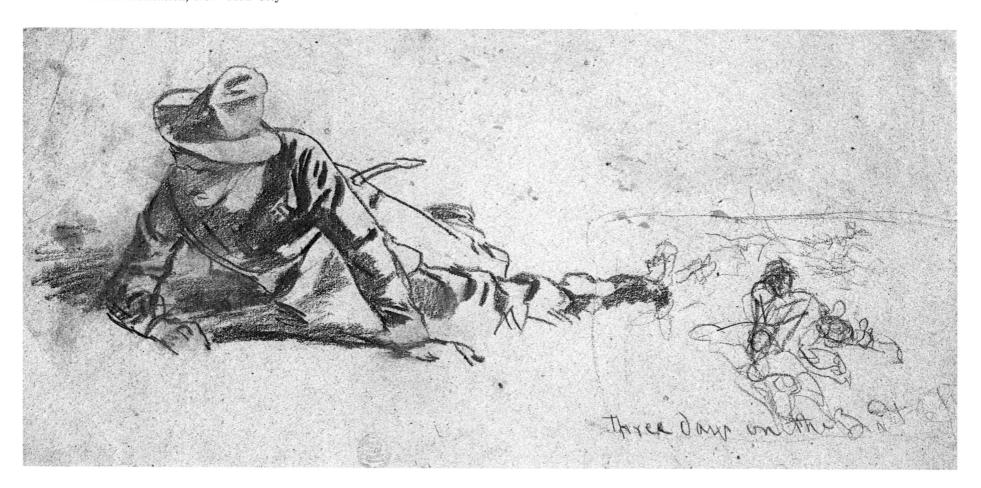

61. *Cavalry Soldier*. 1863.
Black chalk on brown paper,
14 3/8 x 9 1/2″. Cooper-Hewitt
Museum of Decorative Arts and
Design, Smithsonian Institution,
New York City

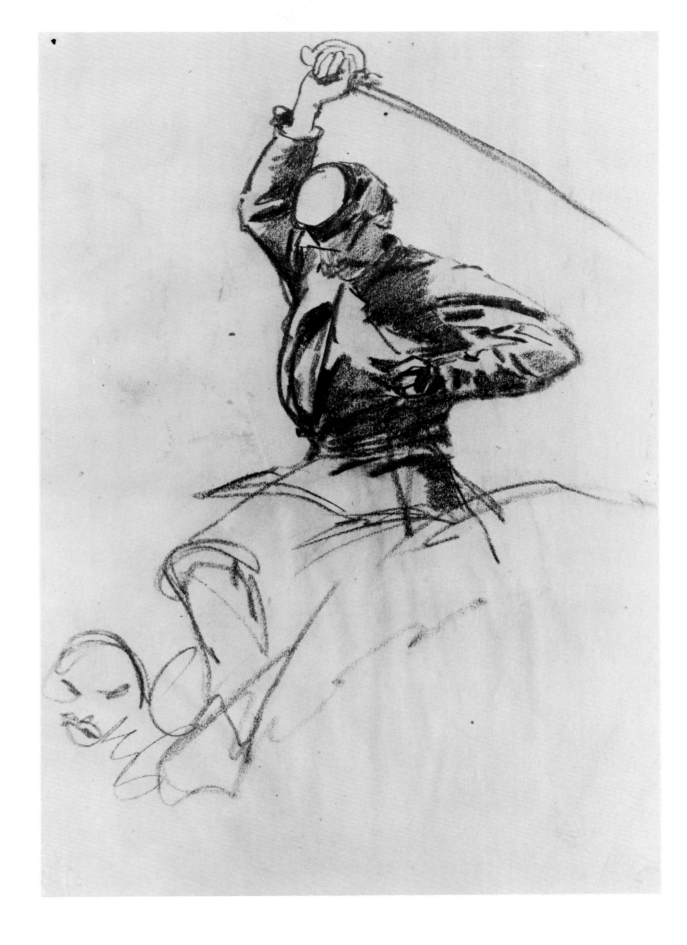

62. *Wounded Soldier Being Given a Drink from a Canteen.*
1864. Charcoal and white chalk on blue-green paper, 14 3/8 x 19 1/2".
Cooper-Hewitt Museum of Decorative Arts and Design,
Smithsonian Institution, New York City

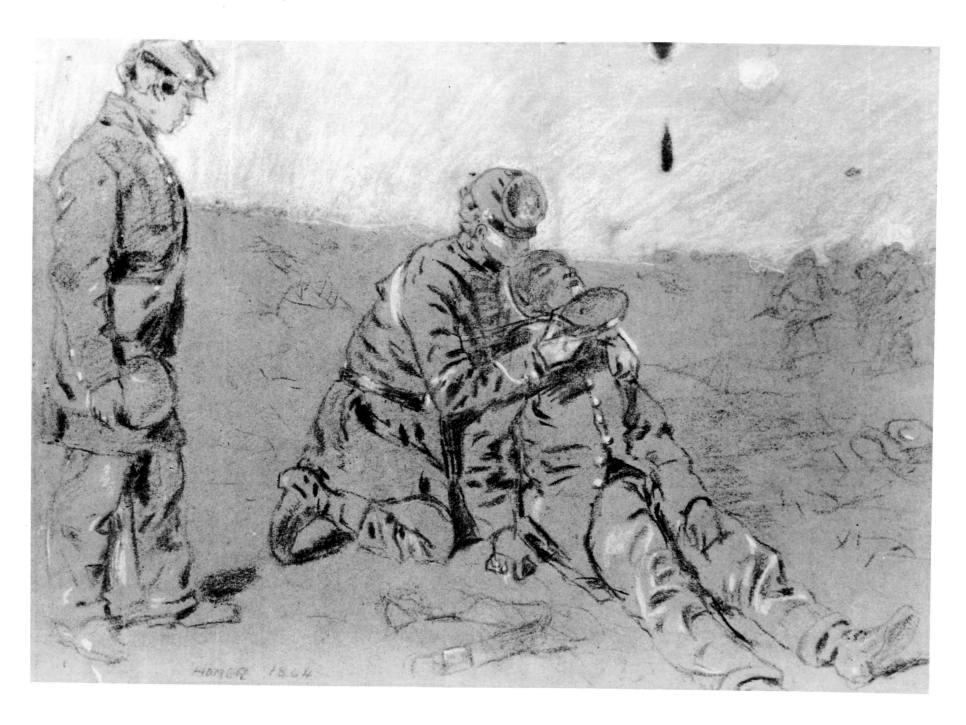

63. *The Walking Wounded*. 1861-62. Pen and brown ink,
4 ³/4 x 7 ¹/2″. Cooper-Hewitt Museum of Decorative Arts
and Design, Smithsonian Institution, New York City

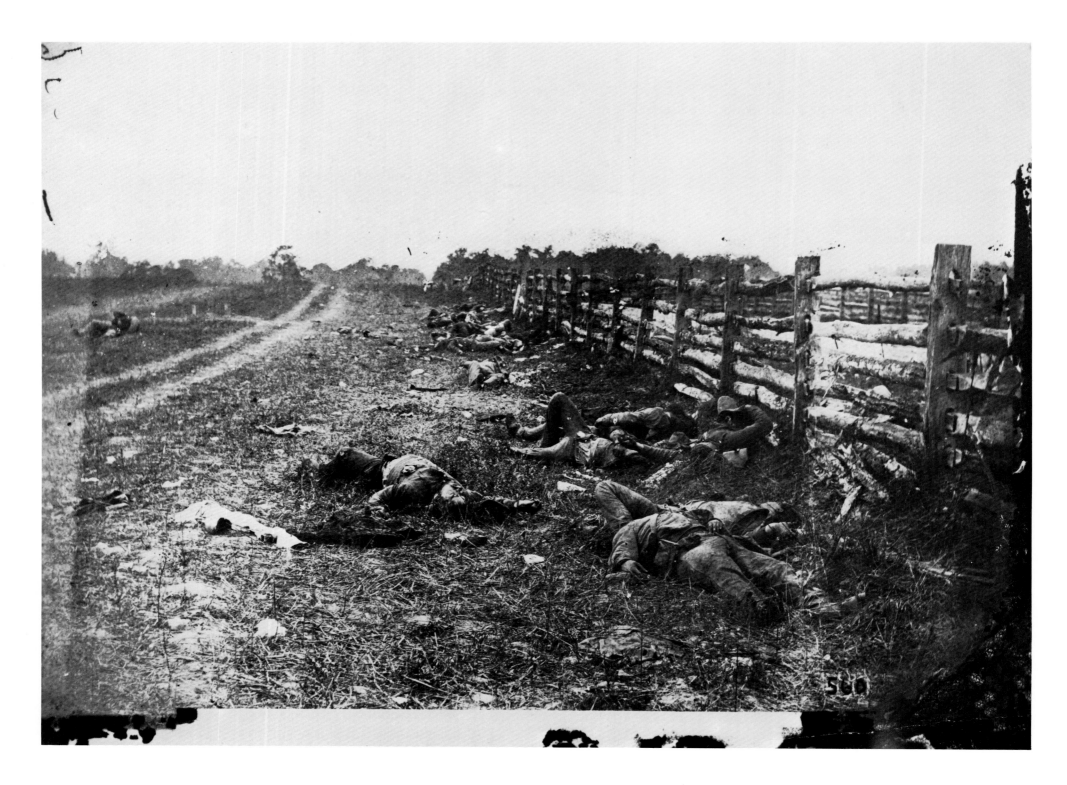

64. Alexander Gardner. *Confederate Dead by a Fence on the Hagerstown Road. Antietam, Maryland.*
September, 1862. Photograph. Library of Congress, Washington, D.C. Mathew B. Brady Collection

The Civil War, like every war, was a tragedy, with more fatalities than in all of America's other wars combined, up to the Viet-Nam conflict. From the French and Indian wars of the 1750s through the hostilities in Korea in the 1950s (with the exception of the Civil War), 606,000 American soldiers died in the line of duty. In the Civil War alone, more than 618,000 men perished in four years.

The North lost 360,022 soldiers. Of that number 67,058 were killed in action, while 43,012 later died of battle wounds. A total of 275,175 Federals received wounds while fighting.

Accurate records do not exist for the Confederate side. The total number of Southern soldiers who died was approximately 258,000. About 94,000 were killed or fatally wounded in battle. No figures exist for the number of Confederates wounded in action.[40]

For every man killed in battle, two men died behind the lines from wounds or from such maladies as smallpox, measles, pneumonia, and intestinal disorders. Richard H. Shryock, the distinguished American historian and librarian-scholar, has analyzed our tendency to forget the suffering engendered by the war:

> Current historiography probably has much to do with it. The political and military traditions, plus the apparent necessity for abstraction, rob historical writings of that realism which alone can convey a sense of the suffering involved in a great war.

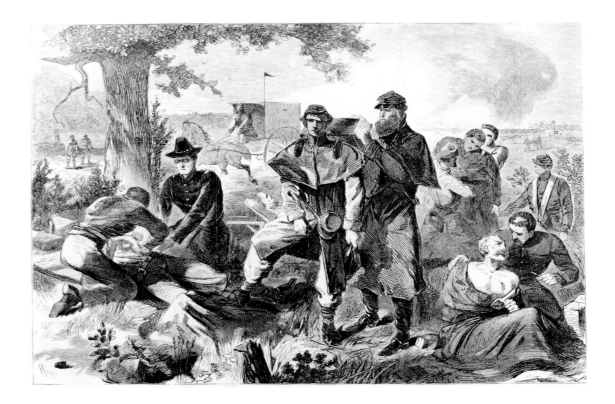

65. *The Surgeon at Work at the Rear During an Engagement.* Published in *Harper's Weekly*, July 12, 1862. Wood engraving, 9 1/8 x 13 3/4''. The Metropolitan Museum of Art, New York City. Harris Brisbane Dick Fund, 1929

An historian's description of the battle of Gettysburg is likely to tell of what occurred to Lee's right wing, or to Longstreet's corps, but rarely of what happened to the bodies of plain John Jones and the thousands like him. . . .

> The historians might, however, picture reality and convey a sense of the costs involved if, in describing campaigns, they gave less space to tactics in the field and more to tactics in the camps and hospitals. There, after all, is where most of the men were lost.[41]

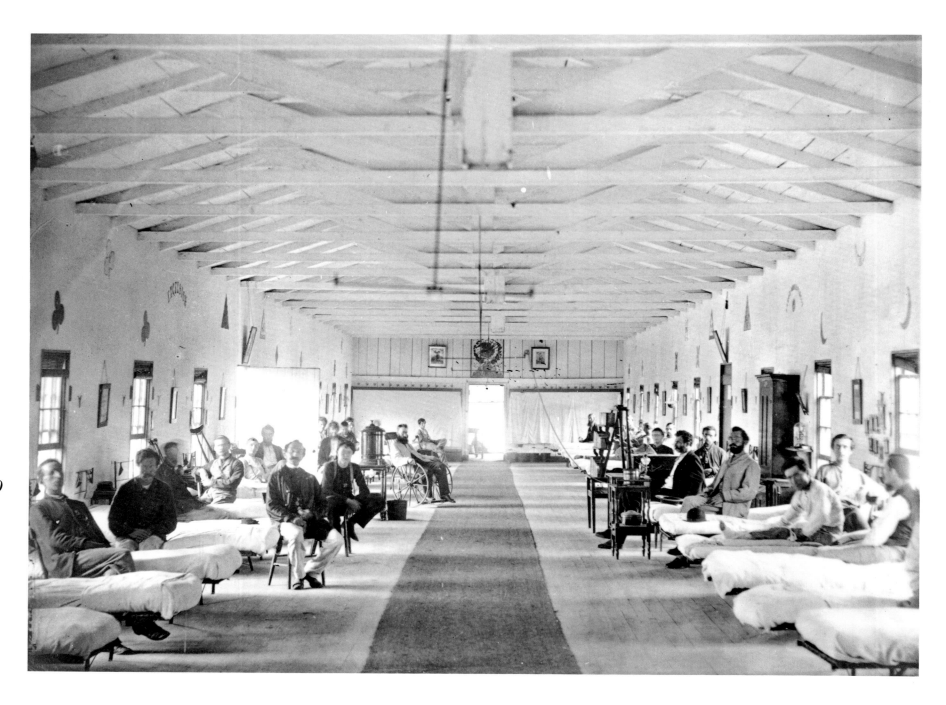

66. Anonymous. *Patients in Ward K of Armory Square Hospital, Washington, D.C.* c. 1865.
Photograph. Library of Congress, Washington, D.C. Mathew B. Brady Collection

67. *Campaign Sketches: The Letter for Home.* 1863.
Lithograph, 14 x 10 7/8″. Prints Division, The New York
Public Library. Astor, Lenox and Tilden Foundations

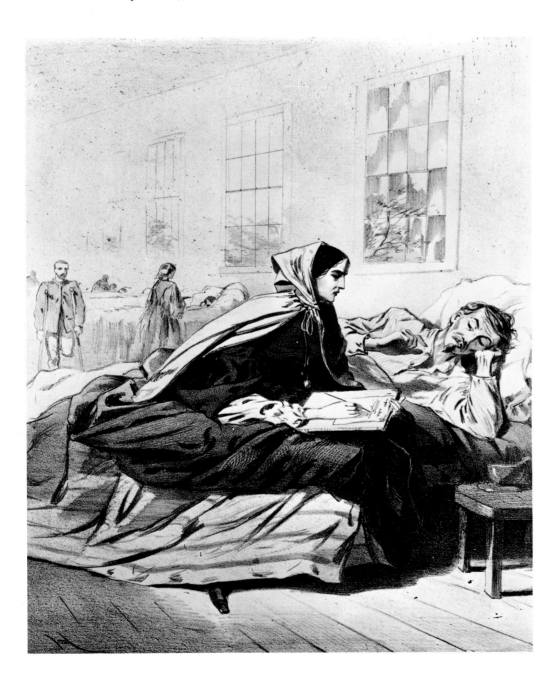

The *Letter for Home*, from
Campaign Sketches, shows the interior
of an army hospital ward, where a
sympathetic woman volunteer is sending
word from a wounded soldier to
parent, brother, or wife. Whitman
describes the sort of help he, as one of
these volunteers, gave:

91

> When eligible, I encourage the men to
> write, and myself, when called upon,
> write all sorts of letters for
> them (including love letters, very
> tender ones).[42]

In my visits to the hospitals I found
it was in the simple matter of
personal presence, and emanating
ordinary cheer and magnetism,
that I succeeded and help'd more
than by medical nursing, or
delicacies, or gifts of money,
or anything else.[43]

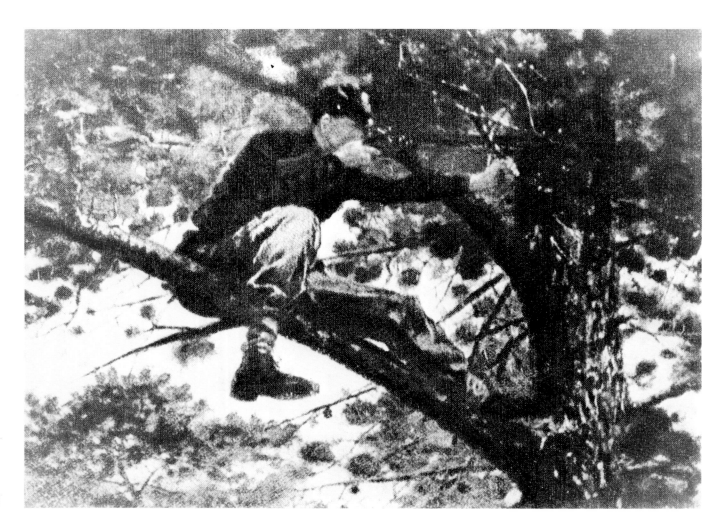

68. *Yankee Sharpshooter.*
1862. Oil on canvas, 16 x 20″.
Collection Mrs. J. Alexander
McWilliams, Dwight, Illinois

oung Homer copied *A Sharp-Shooter on Picket Duty* on the block for *Harper's Weekly* from his first adult oil painting, *Yankee Sharpshooter*, which was completed in the latter part of 1862.[44] The wood engraving presents a bold and beautiful design. In effect, it glamorizes the war. The sharpness of the soldier's eye and the accuracy of his aim are heroized in this composition.

He is seen from surprisingly close up, as if the viewer were sitting on a nearby limb. The marksman's target is not seen, but we know that the glistening gun barrel is aimed at another American.

In a way that mass scenes do not, this single large figure somehow brings home the peculiar horror of the Civil War. Americans shooting Americans, in their own country, just a little over a

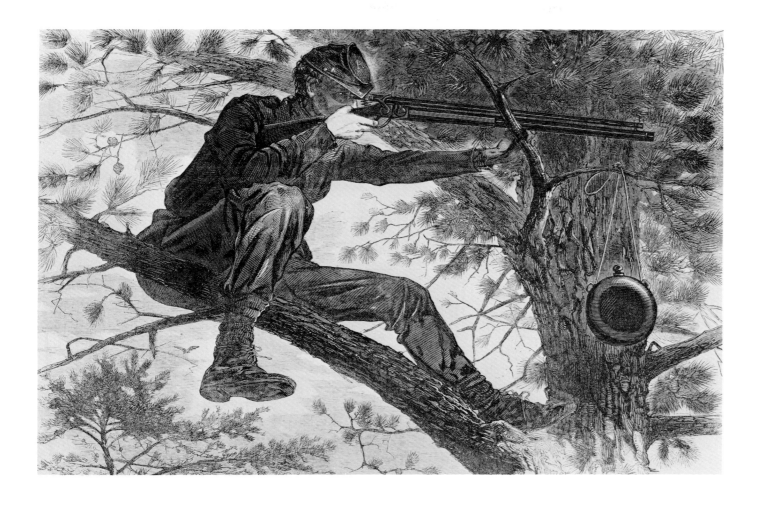

69. *The Army of the Potomac—*
A Sharp-Shooter on Picket Duty.
Published in *Harper's Weekly*,
November 15, 1862. Wood engraving,
9 1/8 x 13 3/4". The Metropolitan
Museum of Art, New York City.
Harris Brisbane Dick Fund, 1929

hundred years ago.

The sharpshooter is perched high in the tree. The warm beauty of the needles, cones, and bark is juxtaposed to the cold, man-made reality of the means of war. Edgar M. Howell, Curator of Military History at the Smithsonian Institution in Washington, described the specific means of war depicted in this wood engraving as follows: "The shoulder gun in this picture is a typical percussion 'match rifle' of the period with telescopic sight. A very similar weapon is on exhibit at the Smithsonian. The sharpshooter appears to have clipped square the visor of his forage cap to enable him to get down over his sight more readily. Shoes and canteen are of the period."[45]

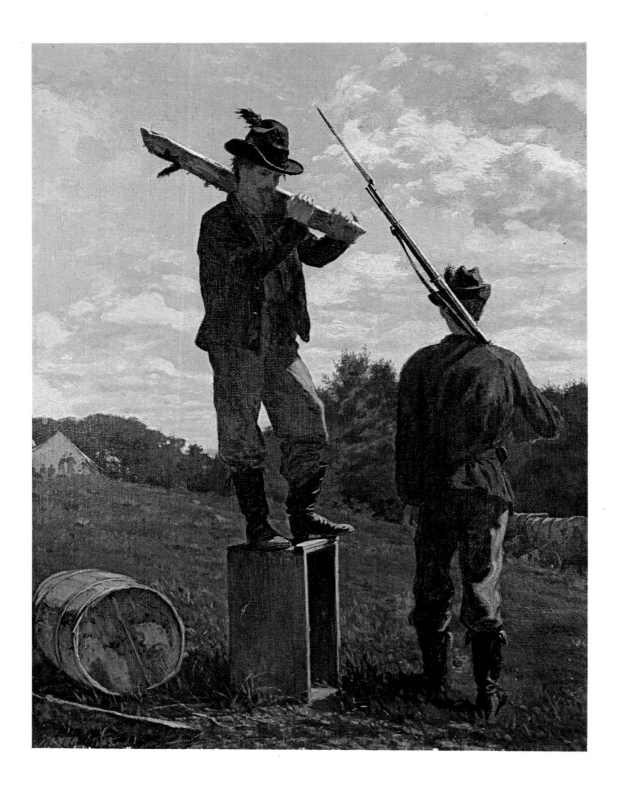

70. *Punishment for Intoxication.*
1863. Oil on canvas, 17 x 13″.
Canajoharie Library and Art
Gallery, Canajoharie, New York

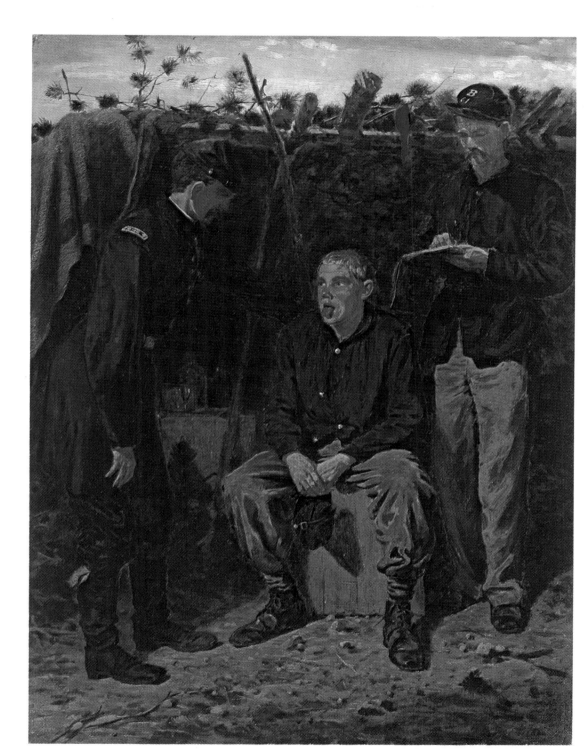

71. *Playing Old Soldier*. 1863.
Oil on canvas, 16 x 12″.
Museum of Fine Arts, Boston.
Ellen Kelleran Gardner Fund

Shortly after painting *Yankee Sharpshooter*, Homer did his second oil—a soldier being punished for intoxication. It is easy to see that Homer had humorous intent, but his painting technique was not up to the joke. The figures look as wooden as the barrel, box, and bough. He later said, "It is about as beautiful and interesting as the button on a barn door."[46] One private soldier, recalling the shoulder-chafing punishment, was willing to swear that somehow, during the three hours he was forced to carry a stick of cordwood, its weight increased about one hundred and seventy pounds.[47]

In another 1863 oil, Homer's humor comes through. A strapping young soldier hangs out his tongue in an unconvincing show of illness, hoping his superior will judge him unfit for active duty.

95

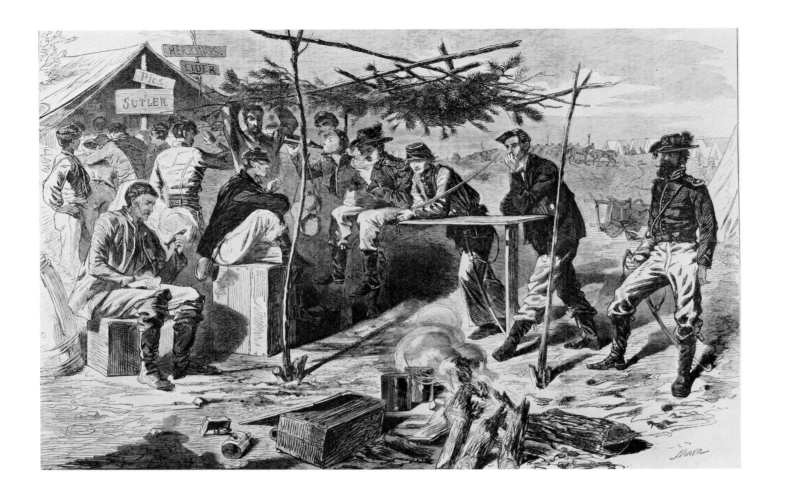

72. *Thanksgiving in Camp.*
Published in *Harper's Weekly*,
November 29, 1862. Wood
engraving, 9 1/8 x 13 3/4".
The Metropolitan Museum of
Art, New York City. Harris
Brisbane Dick Fund, 1929

73. *A Rainy Day in Camp.* 1871. ▶
Oil on canvas, 19 7/8 x 36".
The Metropolitan Museum of
Art, New York City. Gift of
Mrs. William F. Milton, 1923

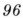omer was economical of his
pictorial ideas. He would make notes of
a typical grouping, or one that was
picturesque, and then would use
the original pencil sketch to bring
veracity to an idealized (or imagined)
scene. The line of horses receding to the
vanishing point was utilized exactly as
sketched, first in the wood engraving
Thanksgiving in Camp and again in
the oil painting *A Rainy Day in Camp.*

Thanksgiving in Camp, an informal
glimpse into an off-duty, holiday scene,
is a formal aesthetic exercise in tonality
by a master graphic artist. Entree to
the scene is gained through the dark
tones in the foreground. Then the story
unfolds itself as the lighter tonality
in the background captures the eye and
reveals the gray of the sutler's tent.
It looks as though there has been a
great demand on this holiday for the
sutler's foods. Sure enough, the man
seated on the left is inspecting his
newly bought herring. Another man
guzzles some cider, his cheeks puffed.
And another munches the pie. Delicious.

In *A Rainy Day in Camp*, the line of
horses recedes into the horizon, leading
(continued)

75. *A Trooper Meditating Beside a Grave.*
Date unknown. Oil on canvas, 16 1/8 x 8″.
Joslyn Art Museum, Omaha, Nebraska

That from these honored dead
we take increased devotion . . .″

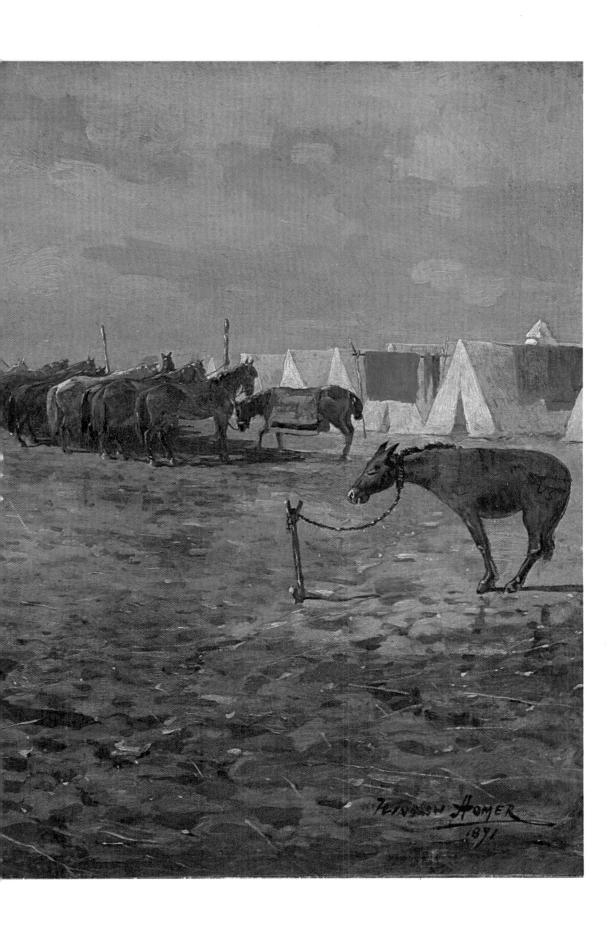

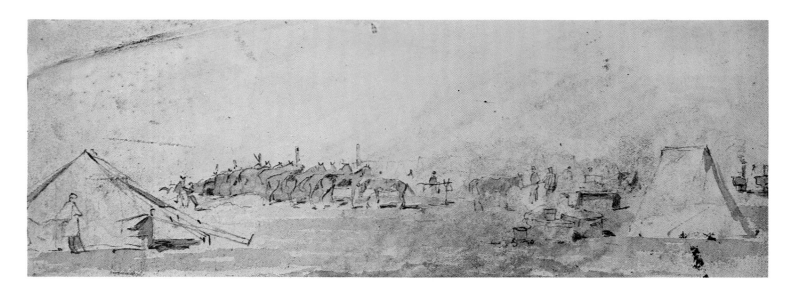

74. *Army Encampment*. 1862. Pencil and
watercolor, 4 3/8 x 9 7/8''. Cooper-Hewitt
Museum of Decorative Arts and Design,
Smithsonian Institution, New York City

the eye on. Dark, filmy clouds blow
across the sky. The whole scene is awash
with a rich, almost golden, brown mud.
The shadows in the foreground help
especially to create this impression.
Miserable men, all wrapped up, huddle
around the campfire. The central
figure is absorbed in his own
thoughts while his companions gaze at
him. He sits with his arms on his knees
in a familiar, self-enclosing, contem-
plative position. The rain makes
movement difficult. In civilian life it
would be a good day to stay at home.

PART 2

THE DECISIVE YEARS

1863-1864

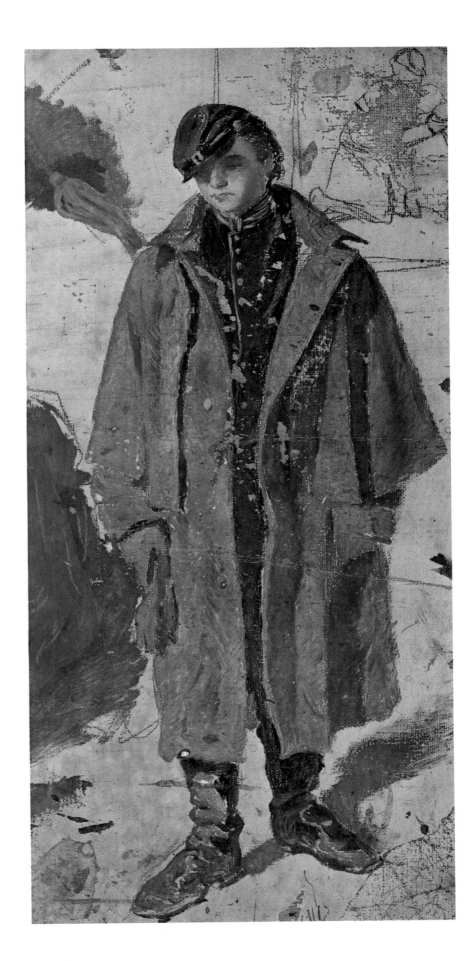

Walt Whitman remarks again and again on the youthfulness of the armies. There were countless numbers of youths and boys, many between fifteen and twenty years old, and only a sprinkling of elderly men.

Nowhere is the boy beneath the soldier seen more clearly or more poignantly than in Homer's masterful *Young Soldier*. The boy seems nearly lost inside the uniform and boots meant for a man. The pictorial evidence in this study, in *The Walking Wounded* (Fig. 63), *Prisoners from the Front* (Fig. 92), and others would seem to indicate that boys served at a lower age than the written draft standards specified.

On paper, the Confederate conscription called for males between the ages of eighteen and thirty-five; and in the waning months of the war these figures went as low as seventeen and as high as fifty. The official Union age limits were eighteen to thirty-five, with unmarried men up to forty-five also liable.[48] It was said that a boy could truthfully swear he was "over eighteen" by writing that number on a piece of paper hidden in his shoe.

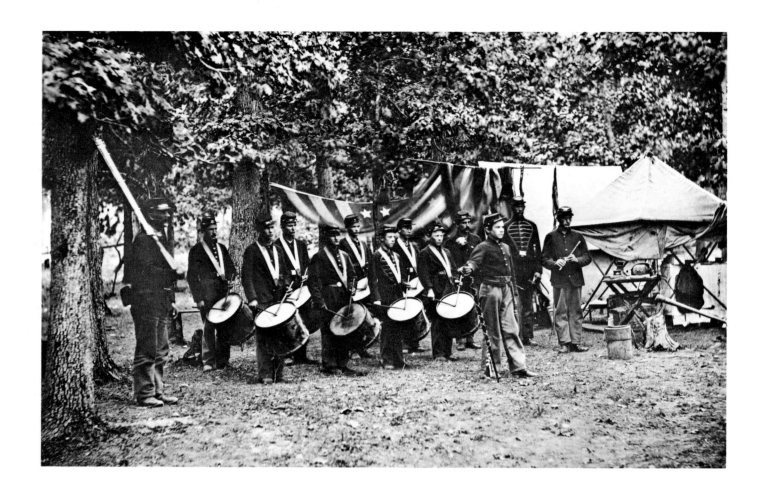

77. Timothy H. O'Sullivan. *Drum Corps, 93rd New York Infantry. Bealeton, Virginia.* August, 1863. Photograph. Library of Congress, Washington, D.C. Mathew B. Brady Collection

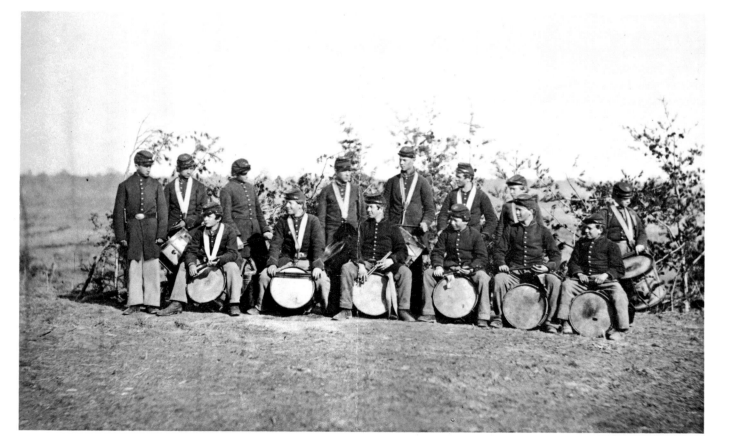

78. Timothy H. O'Sullivan. *Drum Corps, 61st New York Infantry. Falmouth, Virginia.* March, 1863. Photograph. Library of Congress, Washington, D.C. Mathew B. Brady Collection

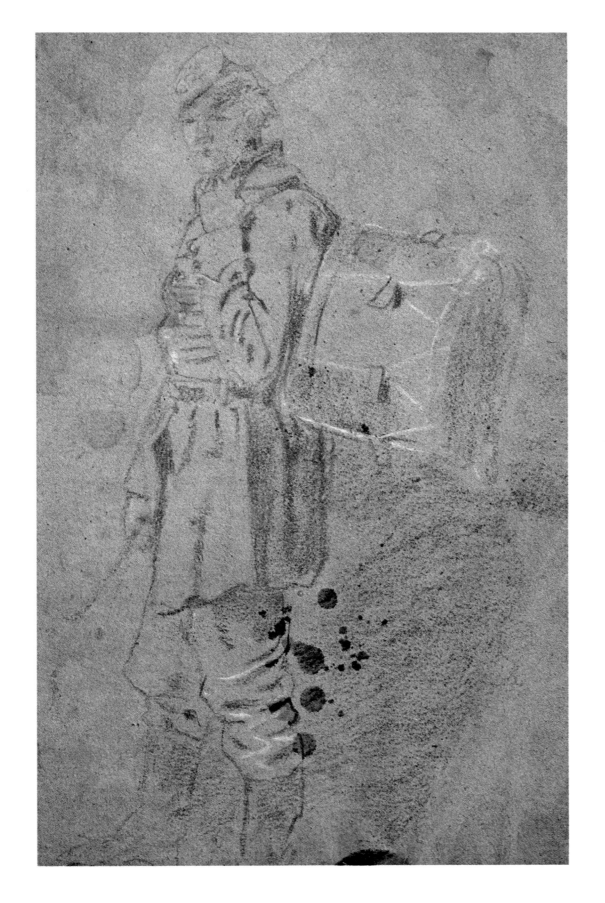

79. *Drummer Boy.* 1864. Black and white chalk on blue paper, 17 x 10 ⁵/₈″. Cooper-Hewitt Museum of Decorative Arts and Design, Smithsonian Institution, New York City

80. *Civil War Soldier*. Date unknown.
Charcoal and white chalk on blue paper,
13 3/4 x 6 7/8''. Museum of Fine Arts, Boston.
M. and M. Karolik Collection

There were some eleven Zouave regiments in the war. They were distinguished by their uniform, which was derived from the Zouaoua tribe in French service in Algeria (about 1830). There were no braver soldiers in Union ranks. The soldiers of the Fifth New York, who were dressed from head to toe in Zouave uniform— tasseled red fez, short blue jacket, broad red sash at the waist, bright red baggy pants, and white canvas leggings—had the highest mortality rate suffered by any Federal regiment in any one battle during the entire war.[49]

Their uniform was colorful but conspicuous on the firing line, a drawback that eventually led to its abandonment under adverse field conditions.

81. *Zouave*. 1864. Black and white chalk on blue paper, 16 7/8 x 7 1/2″. Cooper-Hewitt Museum of Decorative Arts and Design, Smithsonian Institution, New York City

107

82. *Gun Crew Loading a Cannon.* c. 1861. Pencil, 6 1/8 x 9 1/2". Cooper-Hewitt Museum of Decorative Arts and Design, Smithsonian Institution, New York City

Pointing out that Homer did a number of pictures of Zouaves, Edgar M. Howell of the Smithsonian has these interesting comments to make about *Gun Crew Loading a Cannon:*

The members of this fortress artillery section are obviously in Zouave uniform. The very baggy trousers tucked into short leggings; short jacket of Zouave cut, figure third from left has clover leaf design on front of jacket, strictly Zouave; figure in right foreground wearing Zouave fez; figure directly above this latter a Zouave cap with tassel; other figures with regulation style forage caps. Homer apparently has mixed several different type Zouave headgear in this picture."[50]

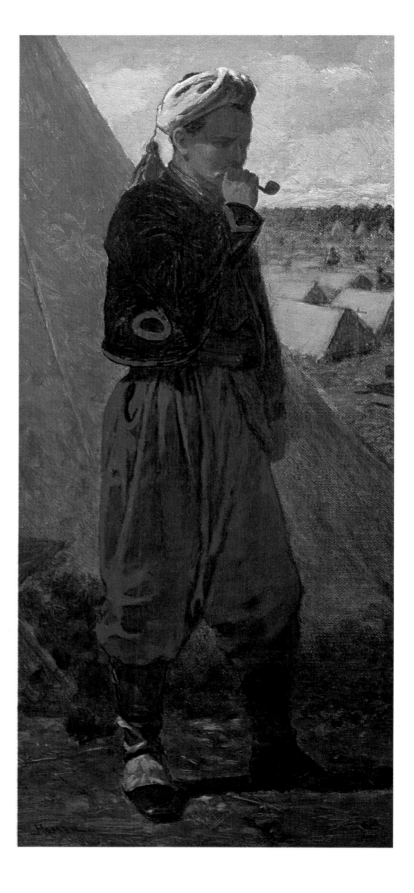

◀ 83. *Zouave.* 1864. Oil on canvas, 14 x 7″. M. Knoedler & Company, New York City

84. Anonymous. *Camp at Army of the Potomac Headquarters; Zouaves in Foreground. Brandy Station, Virginia.* April, 1864. Photograph. Library of Congress, Washington, D.C. Mathew B. Brady Collection

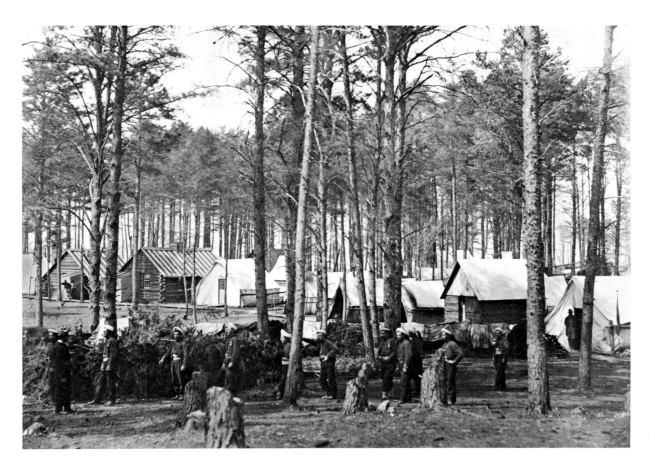

85. Timothy H. O'Sullivan. *Band of the 114th Pennsylvania Infantry (Zouaves). Brandy Station, Virginia.* April, 1864. Photograph. Library of Congress, Washington, D.C. Mathew B. Brady Collection

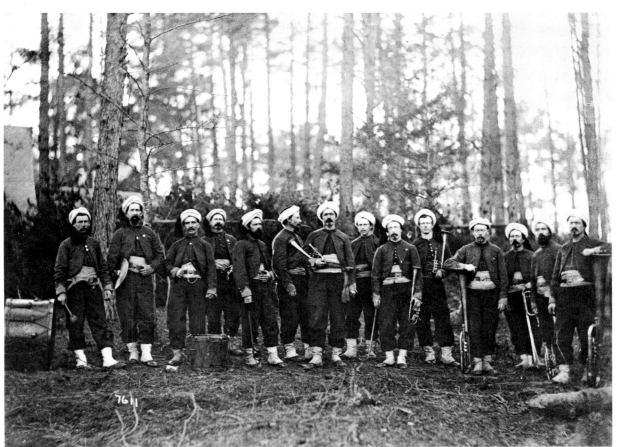

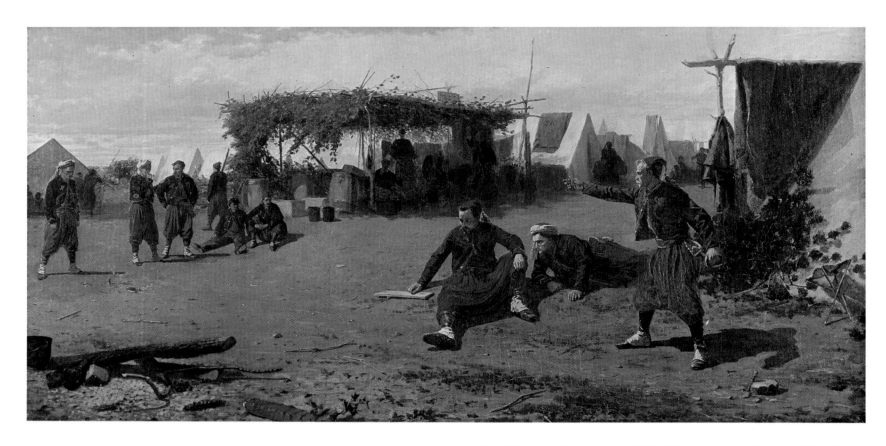

86. *Pitching Horseshoes*. 1865. Oil on canvas, 26 3/4 x 53 3/4".
Fogg Art Museum, Harvard University, Cambridge,
Massachusetts. Gift of Mr. and Mrs. Frederic H. Curtiss

omer's depiction of the colorful
Zouaves reached its height in this
oil painting entitled *Pitching
Horseshoes*. The complementary
colors of the Zouave costume clamor
for our attention—orange-red
baggy pants set off by a trim blue
jacket tinted with purple—and all
this against a sand-brown ground
and light blue sky. Accents of
white occur in the floating clouds and
on Zouave shoes and turbans.

87. Detail of *Pitching Horseshoes*. ▶
The three figures on the right

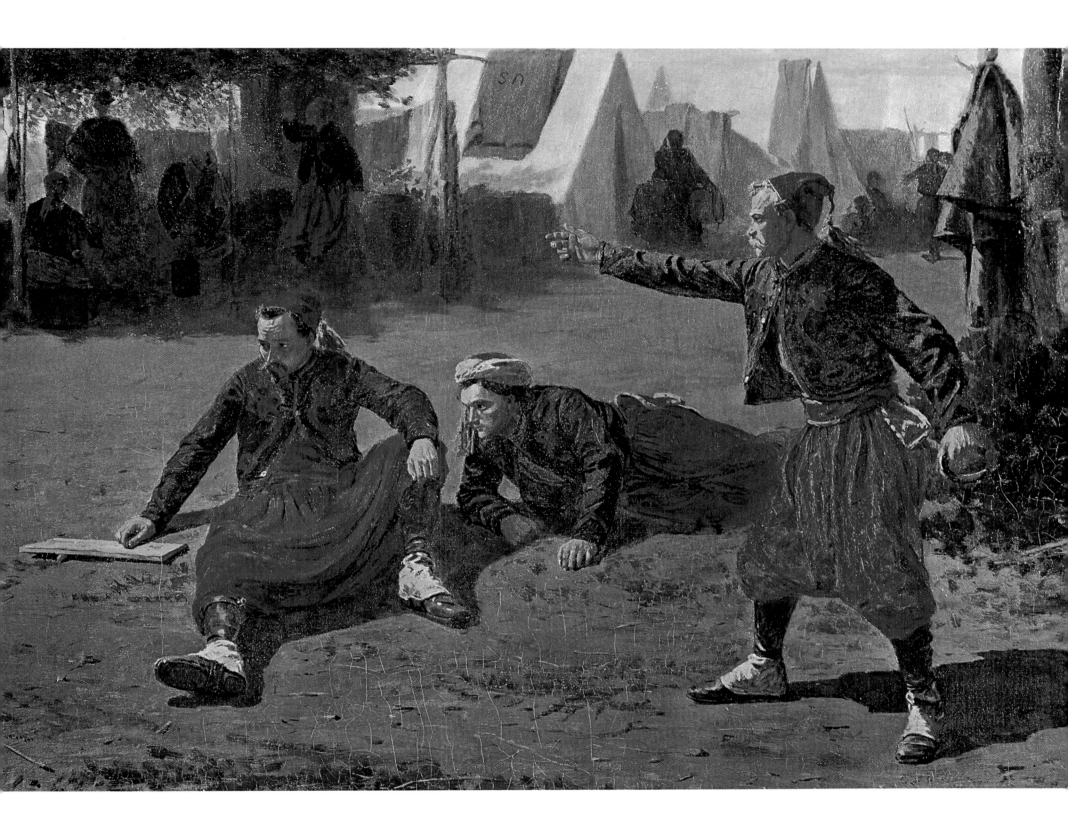

88. *The Briarwood Pipe*. 1864.
Oil on canvas, 16 7/8 x 14 3/4".
The Cleveland Museum of Art.
Mr. and Mrs. William H. Marlatt
Fund

112

89. Detail of *The Briarwood Pipe*.
The figure on the right

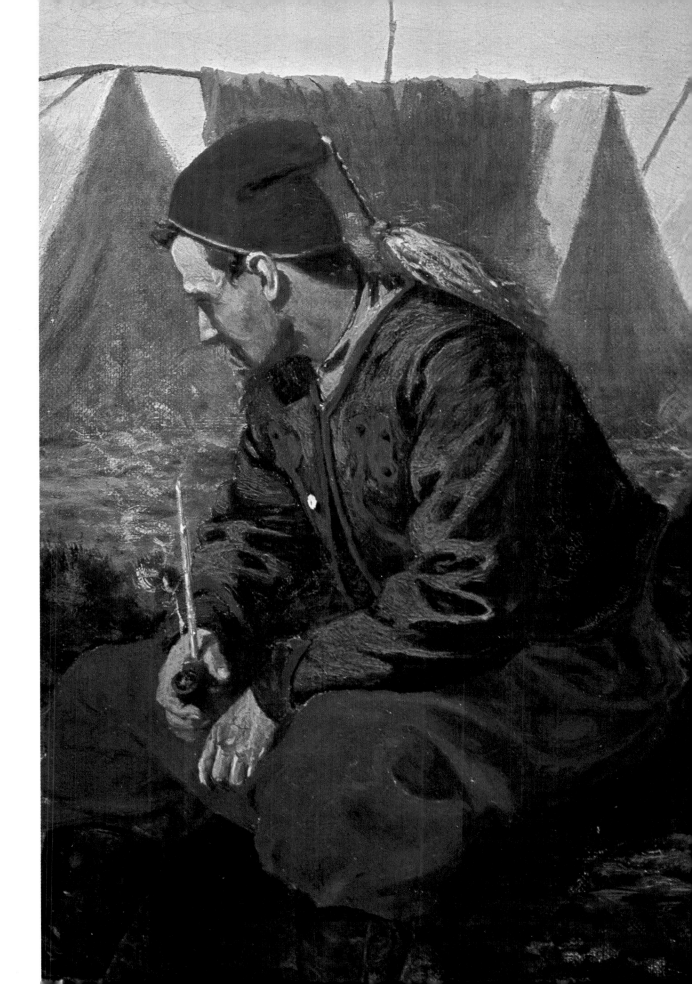

In *The Briarwood Pipe* the
bodily attitudes of the men bespeak
total relaxation. Homer had a
genius for capturing his subjects'
complete absorption in what they
were doing. It is interesting to
compare *The Briarwood Pipe* with
Homer's well-known later oil,
Breezing Up, where the boys in
the boat show their individuality
in bodily expression, yet by their
interdependence form a functional
whole.

Prisoners from the Front is far and away Homer's single most important Civil War work. When finished and exhibited in 1866 at the National Academy of Design, it created a sensation. From that moment Homer's reputation as a major painter of the American scene was established.

Written only two years after the Civil War ended, Henry Tuckerman's important *Book of the Artists*, a comprehensive survey of American artist life, gives succinct but high praise to Homer's *Prisoners from the Front*, describing it as "an actual scene in the War for the Union [which] has attracted more attention, and, with the exception of some inadequacy in color, won more praise than any *genre* picture by a native hand that has appeared of late years." Tuckerman mentions earlier in the book that at the Paris Exposition of 1867, "Winslow Homer's strongly defined war-sketches are examined with much curiosity, especially the well-known canvas, *Prisoners from the Front.*"[51]

Oddly enough, Tuckerman says very little about Homer in his extensive critique of the American art scene in the 1860s. But he does report that the highest critical acclaim America (and France) could offer was given to Winslow Homer and *Prisoners from the Front.*

Further accolade came from the first president of the Metropolitan Museum of Art, John Taylor Johnston, who acquired *Prisoners from the Front* for his private collection, which had no rival in New York nor probably in America.[52]

As we study this painting we realize

(continued)

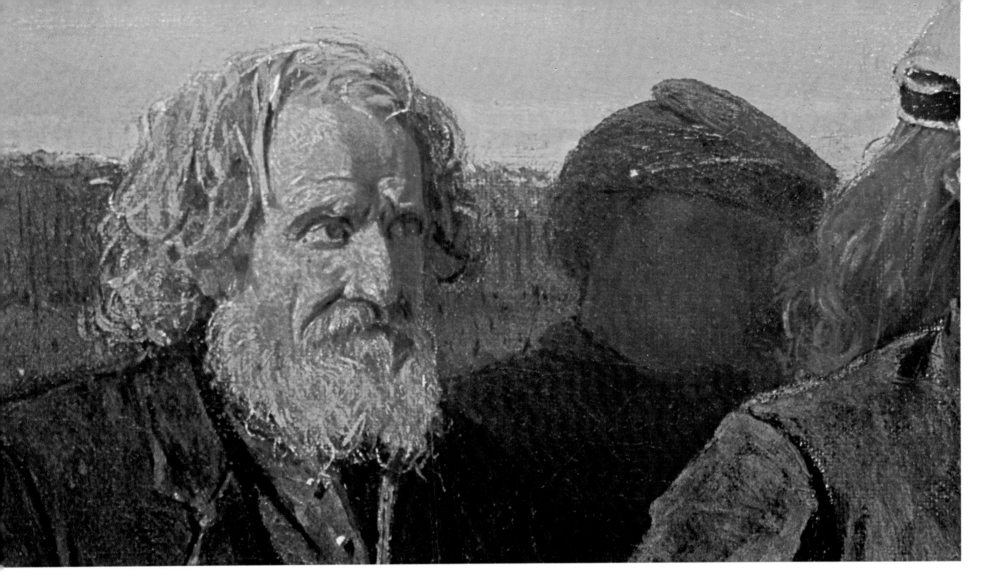

When *Prisoners from the Front* is examined in detail, it becomes easier to see why Homer's contemporary critics said that the painting contributed to a feeling of brotherhood between North and South.[53] The Union officer and the Confederate officer facing him are equals. In a sense, the war is over; there will be no more killing. It is time to close the gap.

At first glance the cut of his jaw might make the Union officer look arrogant, but he should not be dismissed as supercilious. Upon further study it may be seen that his expression is as intense as that of the old Southerner's. He has power over the men before him, but he does not use it. Instead, he seems troubled, perhaps puzzled by the motivation of the Rebels in general and deeply concerned over the inevitable gulf between victor and vanquished.

Painted with the dark palette characteristic of Homer's early work, *Prisoners from the Front* gives

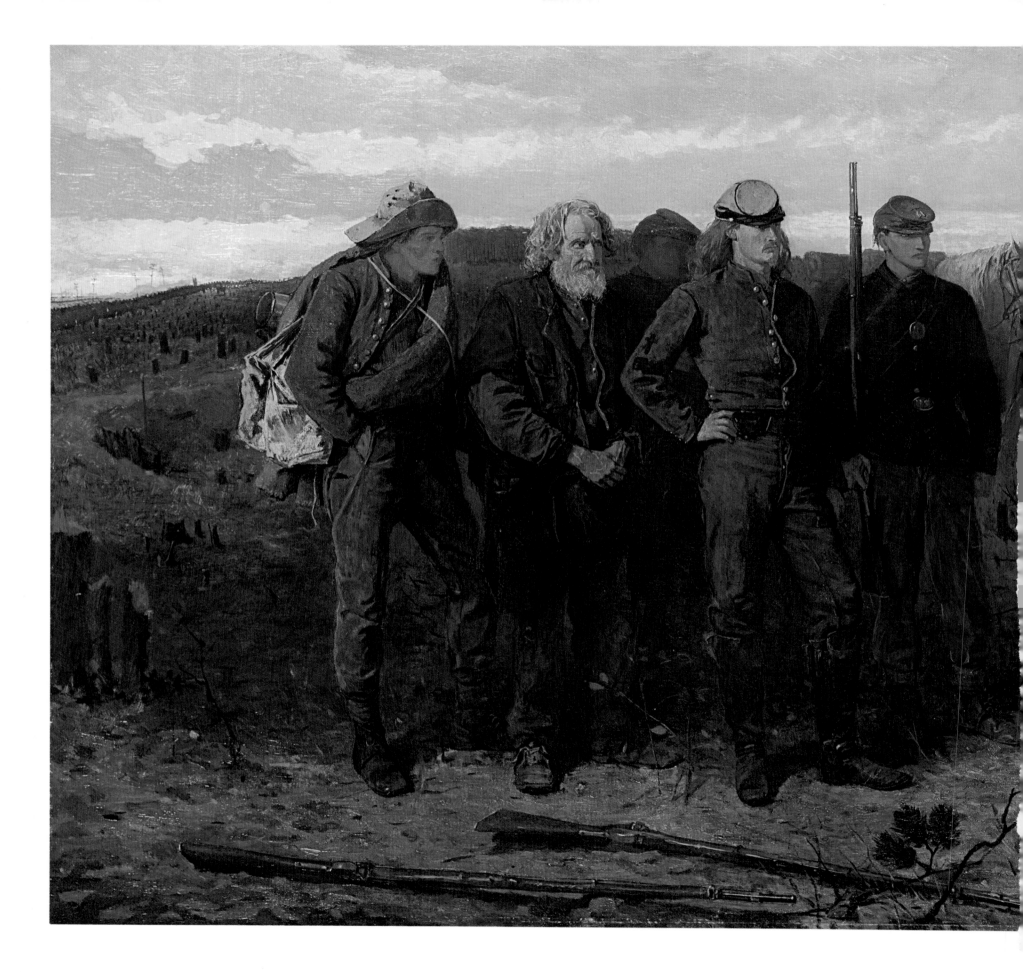

92. *Study of Cavalry
Officer's Boots.* 1862.
Pencil, 6 7/8 x 4 3/4".
Cooper-Hewitt Museum of
Decorative Arts and Design,
Smithsonian Institution,
New York City

that it is nothing short of a pictorial synopsis of the entire war. A young, well-dressed, well-equipped Union officer stands on the right, looking over his Rebel captives. The gap between the two is remarkably expressive. Within the group of prisoners, moreover, Homer shows three types of Confederate soldier: a young officer, hand on hip, stares back at his Yankee captor defiantly, reminding one of the tragedy inherent in Robert E. Lee's attitude; an elderly soldier, bedraggled in dress, holds his hat in his hands; and a young boy, still wearing his pack, looks perplexed rather than openly defiant. How well Homer captured the essence of these Southern soldiers can be seen by comparing the painting with a photograph of three Confederate prisoners taken at Gettysburg in July, 1863.

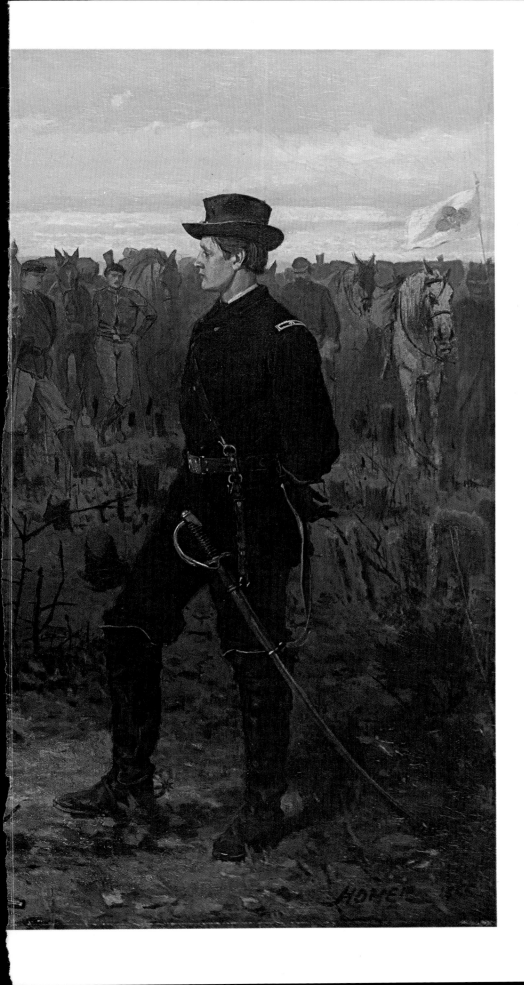

116

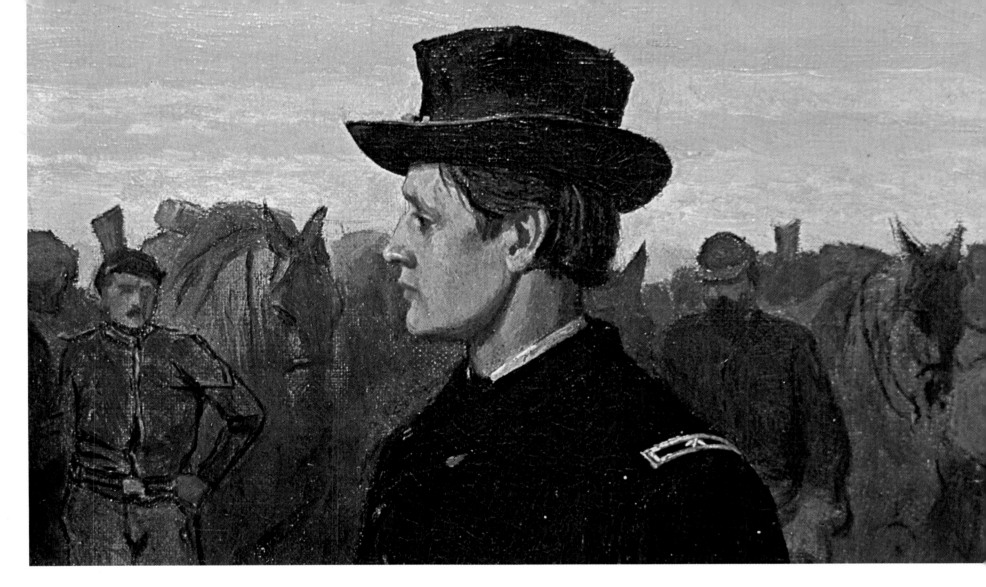

the impression of frozen movement, as if a second in the flow of time has been captured on canvas. But on closer inspection we realize that the feeling of dynamic equilibrium in the picture is the result of very careful composition on Homer's part.

Mr. Howell points out that in this picture the Union "officer is in correct dress of a general officer or general staff officer except for non-regulation campaign hat (normal wear for Union officers)."[54]

There are valid grounds for identifying the Union officer as Major General Francis C. Barlow, to whose staff Homer was attached. Barlow was slight of build, which gave him a youthful appearance and led to the sobriquet of "boy general."[55] General Ulysses S. Grant, commander-in-chief of the Union army, often had high praise for Barlow and spoke of his "pushing forward with great vigor" and capturing "several hundred prisoners."[56]

95. *A Shell in the Rebel Trenches.* Published in *Harper's Weekly,* January 17, 1863. Wood engraving, 9 1/8 x 13 3/4". The Metropolitan Museum of Art, New York City. Harris Brisbane Dick Fund, 1929

HOMER AND THE WOOD ENGRAVING

After Homer's name in the lower left- or right-hand corner of each wood engraving, there appears the abbreviation *Del* for the Latin *Delineavit* or *Delinquit* ("he drew it"). In the case of *Harper's Weekly* and other illustrated journals, it is important to note that the functions of the creative artist and the engraver were separate. When Homer supplied an original design, it was carved into the block by skilled artisans who were, however, not always true to the artist's original intentions. What was loose and flowing in the drawing may appear stiff and graceless in the print by a less talented engraver.

The relief method of print making, in which the lines to be printed are left in relief, was revolutionized by turning the wood block on end so that the lines could be carved into the end grain like lines engraved on a metal plate. The new process of wood engraving made pictorial journalism possible in the middle of the nineteenth century. The smooth, hard grain of the boxwood blocks enabled the relatively rapid cutting of illustrations with exquisite detail.

In his drawings on the block Homer used every gradation between black and white. This, in addition to his simplicity of statement and definitive line, helps to account for the striking quality of his wood engravings.

96. *Winter-Quarters in Camp—The Inside of a Hut.* Published in *Harper's Weekly*,
January 24, 1863. Wood engraving, 9 1/8 x 13 7/8". The Metropolitan Museum of Art,
New York City. Harris Brisbane Dick Fund, 1929

97. *Pay-Day in the Army of the Potomac.* Published in *Harper's Weekly,*
February 28, 1863. Wood engraving, 13 ⁵/₈ x 20 ¹/₂″. The Metropolitan Museum of Art,
New York City. Harris Brisbane Dick Fund, 1929

The appearance of the paymaster was erratic. No one was certain when he would arrive; the only sure thing was that there would be a long time between his visits. When he did come, the men were mustered and paid off by companies. Family men sent money home to their wives and children. But many men were in no mood to defer present satisfaction for future benefit and would go through three months' accumulated pay in as many hours at the sutler's or at cards.

The tender scene entitled *The Letter* depicts a soldier's wife in homey surroundings, reading a letter from the front lines. By her side is her son, whose face, masterfully sketched, expresses the look of a young boy grown to be a source of strength beyond his years. It calls to mind the scene in Louisa May Alcott's *Little Women* in which Mrs. March reads her daughters the letter from their father, who is ministering in the war.

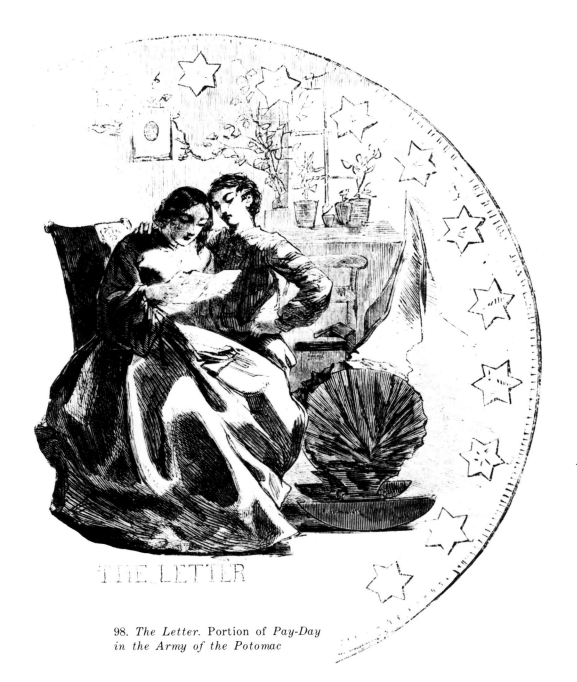

THE LETTER

98. *The Letter.* Portion of *Pay-Day in the Army of the Potomac*

123

left: 99. *Great Sumter Meeting in Union Square, New York, April 11, 1863.* Published in *Harper's Weekly*, April 25, 1863. Wood engraving, 9 1/8 x 13 3/4 ". The Metropolitan Museum of Art, New York City. Harris Brisbane Dick Fund, 1929

below: 100. *Home from the War.* Published in *Harper's Weekly*, June 13, 1863. Wood engraving, 9 1/4 x 14". The Metropolitan Museum of Art, New York City. Harris Brisbane Dick Fund, 1929

On the second anniversary of the firing on Fort Sumter a huge rally was held at Union Square in New York City. Six stands were erected for the orators and musicians. The statue of Washington was decorated with streamers and a rosette of red, white, and blue, and trimmed with evergreens. Most of the buildings on Broadway had the flag flying during the day. Handkerchiefs and flags were waved by the ladies who filled the doorways, windows, and balconies that bordered the square. In a panoramic scene for *Harper's Weekly*, Homer captured the drama of this magnificent mass meeting of New Yorkers who, forgetting party affiliations, showed their allegiance to the flag which had been struck from its staff by rebel cannon at Fort Sumter.

Homer also captured the private moments of the war for the readers of *Harper's*. In *Home from the War* the broad outlines and large figures are outstanding. There is an earnestness of feeling reflected in the faces of son coming home to mother, husband to wife, father to daughter. Hands, face, cloth, and drapery set up a counterpoint of texture resulting from the combined melodic lines of feature and fold.

101. *The Approach of the British Pirate "Alabama."* Published in *Harper's Weekly*, April 25, 1863. Wood engraving, 13 3/4 x 9 1/8". The Metropolitan Museum of Art, New York City. Harris Brisbane Dick Fund, 1929

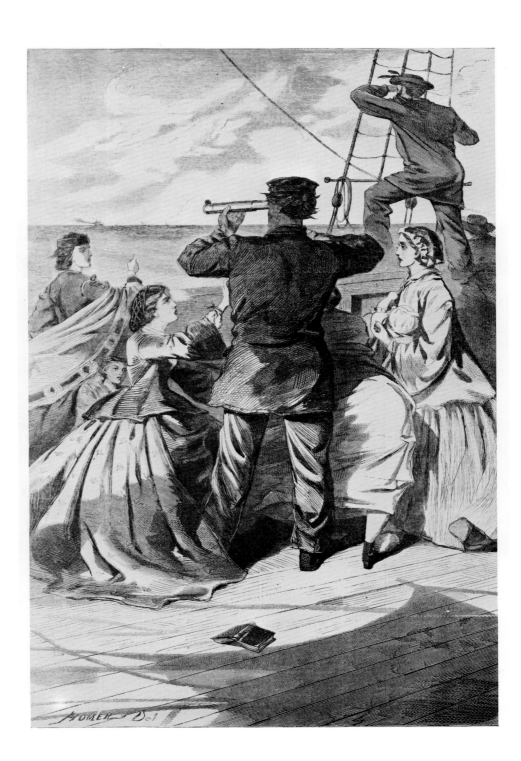

The raider appears as a speck far off on the horizon. The emphasis is on the human aspect, rather than the military.

In June, 1861, J. D. Bulloch reached England as Confederate agent to contract for warships with private builders. The United States minister to Great Britain, C. F. Adams, brought before the British authorities evidence of the illegal character of the *Alabama,* but by a tragicomedy of errors the vessel had left port under pretense of a trial run by the time the officers of the Crown ordered her to be detained. The *Alabama* became the terror of American vessels; she had sunk, burned, or captured more than sixty ships before she was sunk by the *Kearsarge* off Cherbourg Harbor in July of 1864.

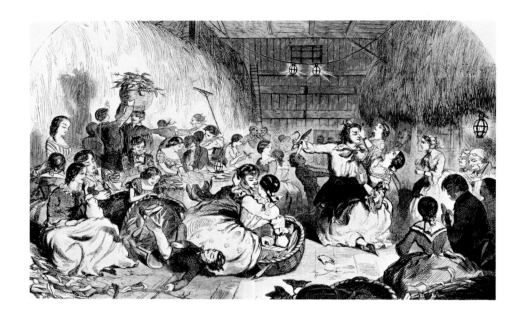

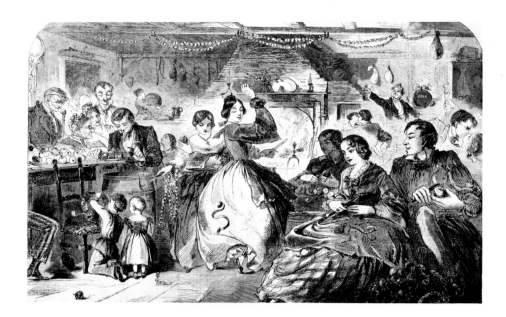

above left: 102. *Husking the Corn in New England.* Published in *Harper's Weekly,* November 13, 1858. Wood engraving, 9 1/4 x 13 7/8". Prints Division, The New York Public Library. Astor, Lenox and Tilden Foundations

above right: 103. *Fall Games—The Apple-Bee.* Published in *Harper's Weekly,* November 26, 1859. Wood engraving, 9 1/8 x 13 3/4". Prints Division, The New York Public Library. Astor, Lenox and Tilden Foundations

right: 104. Anonymous. *Three Officers of the 1st Connecticut Heavy Artillery. Fort Brady, Virginia.* 1864. Photograph. Library of Congress, Washington, D.C. Mathew B. Brady Collection

Perhaps because home was around the corner, just up the road but still agonizingly far away, the longing was greater and the soldiers of the Civil War, North and South, did more singing than any in our country's history.

"Home, Sweet Home" was, by all odds, the favorite song. Moving stories are told of times when one side in its encampment would begin this affecting tune, echoed quickly by the other side, until the whole scene reverberated with the music.[57]

Home, Sweet Home was painted about 1863. It catches two soldiers in reverie. Their abstracted attitude, as they listen to the regimental band in the background, is ironically heightened by the drape of their battle-worn clothes.

Homer knew what the Northern soldiers must be remembering; his earlier New England scenes had faithfully portrayed many good-natured Yankee customs.

The lad who found a red ear of corn during the husking was entitled to kiss his favorite girl.

At apple bees every girl tried to pare an apple without tearing the peeling and then would fling the single peel over her shoulder. When it dropped to the floor, it formed the first initial of her sweetheart, or so the story goes.

Between the anecdotal gaiety of these early New England scenes, celebrating the harvest as well as young love, and the stark understatement of *Home, Sweet Home* there is a world of difference. In the comparison, we are looking at an artist growing up. The more mature Homer is able to concentrate on the internal life of his subjects, revealing their moods, thoughts, and feelings in the quietest of moments.

105. *Home, Sweet Home.* c. 1863. Oil on canvas, 21 x 16″. Collection Mr. and Mrs. Nathan Shaye, Detroit

106. *Campfire with Soldiers Grouped About.* 1862. Pencil and gray wash, 6 3/4 x 9 3/4''. Cooper-Hewitt Museum of Decorative Arts and Design, Smithsonian Institution, New York City

107. *Halt of a Wagon Train.* Published in *Harper's Weekly,*
February 6, 1864. Wood engraving, 13 3/8 x 20 1/4″. The Metropolitan Museum
of Art, New York City. Harris Brisbane Dick Fund, 1929

108. *Reveille.* 1865. Oil on canvas, 13 1/4 x 19 1/2". Collection Cecil D. Kaufmann, Washington, D.C.

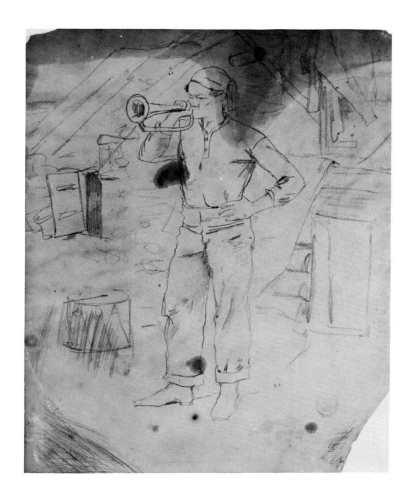

Nearly a dozen drum or bugle calls regulated the daily round of camp life.[58] They were:

Reveille
Breakfast Call
Sick Call or Fatigue Duty
Guard Mounting and Inspection,
 sounded at 8:00 A.M.
Drill Call
"Roast-beef" Call: lunch
Drill Call
Call to Retreat: roll call, inspection,
 and dress parade
Call to Supper
Tattoo: roll call
Taps

Incidentally, "Taps" was composed in July of 1862 by General Daniel Butterfield, a brigade commander in the Army of the Potomac, and was first played at Berkeley, Virginia, by Butterfield's bugler, Oliver Willcox Norton. Confederate forces stationed across the James River heard the tune and later sounded it as the last rites of one of their most famous generals, Stonewall Jackson.[59] Thus one of the world's most poignant and haunting melodies, signaling the end of the day and the mourning of the dead, became the official "Taps" of the United States armed forces.

above left: 109. *Bugler Wearing Zouave's Cap.* c. 1862. Pencil on brown paper, 12 5/8 x 9 7/8''. Cooper-Hewitt Museum of Decorative Arts and Design, Smithsonian Institution, New York City

above right: 110. *Bugler.* 1862. Pencil, 9 x 6 3/4''. Cooper-Hewitt Museum of Decorative Arts and Design, Smithsonian Institution, New York City

111. *Drummers Resting Before Tents.* 1863-64. Pencil and brown wash on brown paper, 6 3/4 x 9 3/4".
Cooper-Hewitt Museum of Decorative Arts and Design, Smithsonian Institution, New York City

112. *Sketch of Soldiers.* 1862. Pencil, pen, and brown ink, 4 7/8 x 3 1/2''. Cooper-Hewitt Museum of Decorative Arts and Design, Smithsonian Institution, New York City

113. *Standing Officer.* 1862. Pencil, 4 3/4 x 3 3/8''. Cooper-Hewitt Museum of Decorative Arts and Design, Smithsonian Institution, New York City

114. *An Army Encampment.* 1862. Pencil, 11 5/8 x 24 3/4''. Cooper-Hewitt
Museum of Decorative Arts and Design, Smithsonian Institution, New York City

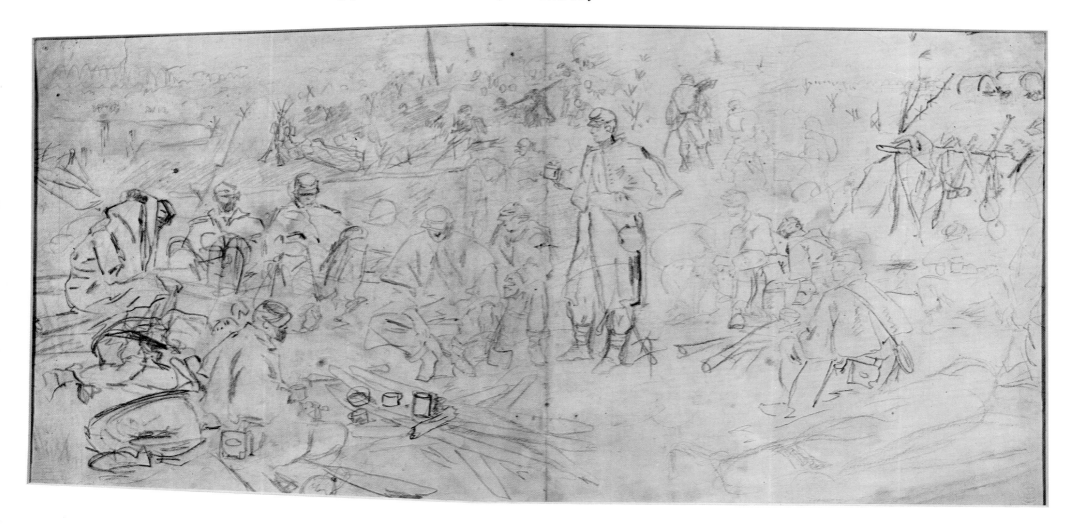

115. *Soldier with Sword and Pipe.* 1862.
Pencil, 5 1/8 x 3 1/2″. Cooper-Hewitt
Museum of Decorative Arts and Design,
Smithsonian Institution, New York City

116. *Soldier with Pipe in Mouth.* 1862.
Pencil, 5 1/2 x 3 1/4″. Cooper-Hewitt
Museum of Decorative Arts and Design,
Smithsonian Institution, New York City

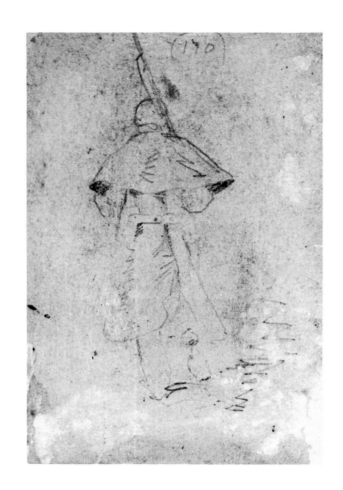

117. *Sketch of Civil War Soldier.* 1862.
Pencil, 4 7/8 x 3 1/2''. Cooper-Hewitt
Museum of Decorative Arts and Design,
Smithsonian Institution, New York City

118. *Sketch of Civil War Soldier.* 1862.
Pencil, 4 3/4 x 3 1/4''. Cooper-Hewitt
Museum of Decorative Arts and Design,
Smithsonian Institution, New York City

119. *Seated Soldier.* 1862.
Pencil, 3 1/2 x 4 5/8". Cooper-Hewitt
Museum of Decorative Arts and Design,
Smithsonian Institution, New York City

120. *Soldier Seated on a Box.* 1862.
Pencil, 4 3/4 x 3 3/8". Cooper-Hewitt
Museum of Decorative Arts and Design,
Smithsonian Institution, New York City

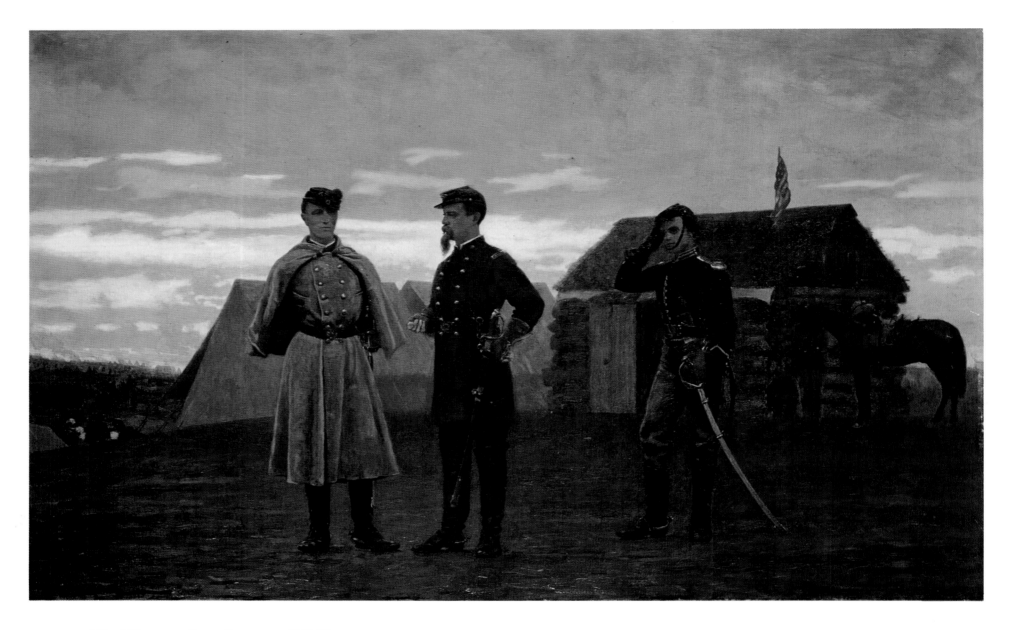

121. *Officers at Camp Benton.* c. 1861-65.
Oil on canvas, 21 x 33″. Boston Public Library

122. *Four Studies of Soldiers' Heads.*
c. 1863. Black chalk on brown paper,
16 7/8 x 9 7/8''. Cooper-Hewitt Museum
of Decorative Arts and Design,
Smithsonian Institution,
New York City

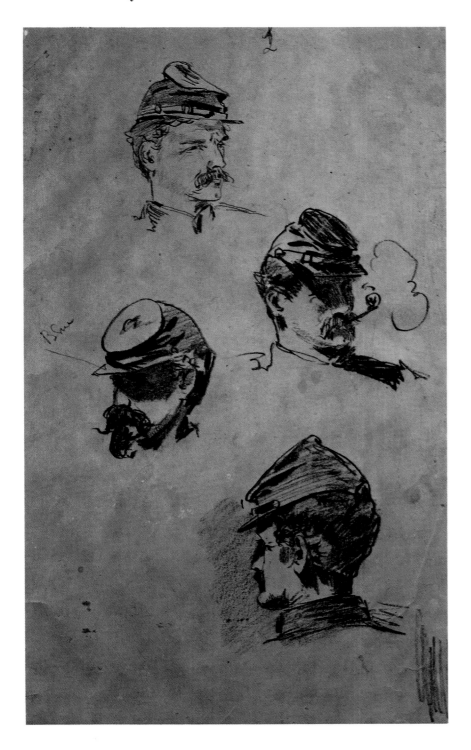

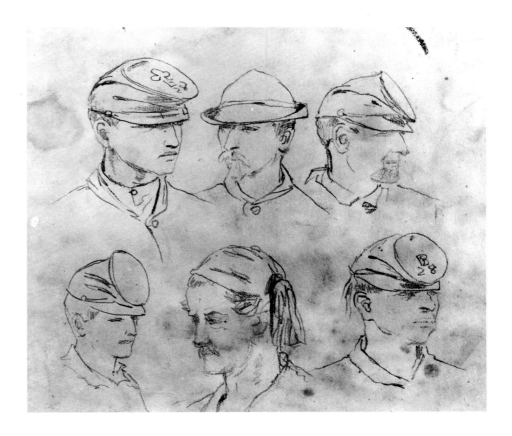

123. *Six Studies of Soldiers' Heads.* 1862.
Pencil, 9 5/8 x 11 3/8''. Cooper-Hewitt Museum
of Decorative Arts and Design, Smithsonian
Institution, New York City

139

HOMER AND LITHOGRAPHY

Homer's style shows through clearly in his lithographs for *Campaign Sketches.* This is so because lithography involves a reproduction technique which has the most in common with drawing.

To create a lithograph, Homer drew with a greasy crayon directly on the lithographer's stone. In this case there was no engraver to translate the design into lines cut into the block; therefore, the relationship of the print to the artist's original idea is more direct, more immediate.

Next in the lithographic process, once the drawing is completed to the artist's satisfaction, the stone is moistened with water, which will not stick to the greasy lines left by the crayon. Then a greasy ink is rolled over the stone, adhering only to the crayon lines because of the natural antipathy of oil and water. Paper pressed onto the stone will pick up ink only from the image drawn by the artist.

140

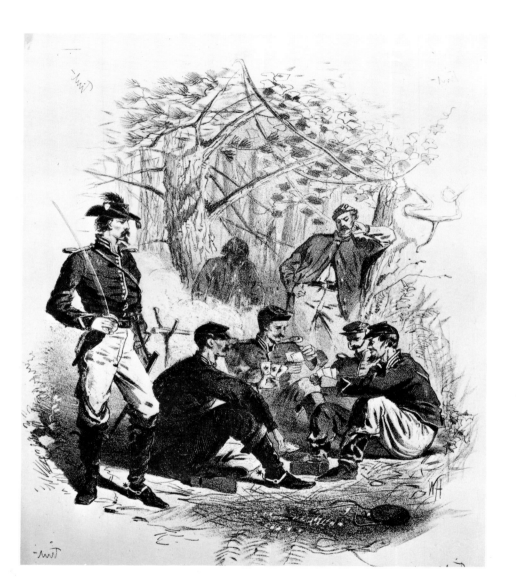

124. *Campaign Sketches: A Pass Time: Cavalry Rest.*
1863. Lithograph, 14 x 10 ⁷/₈″. Prints Division, The New York Public Library. Astor, Lenox and Tilden Foundations

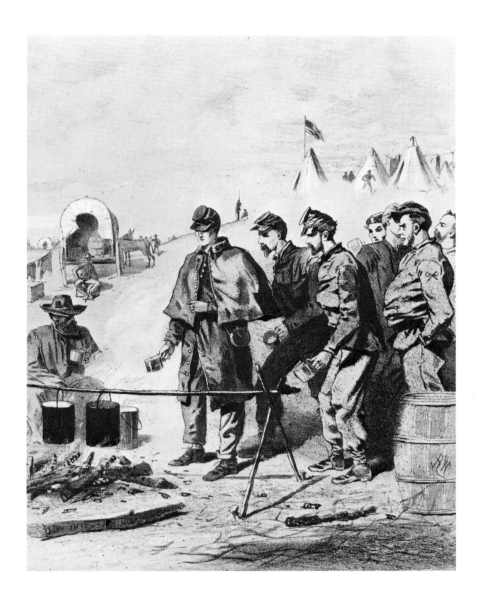

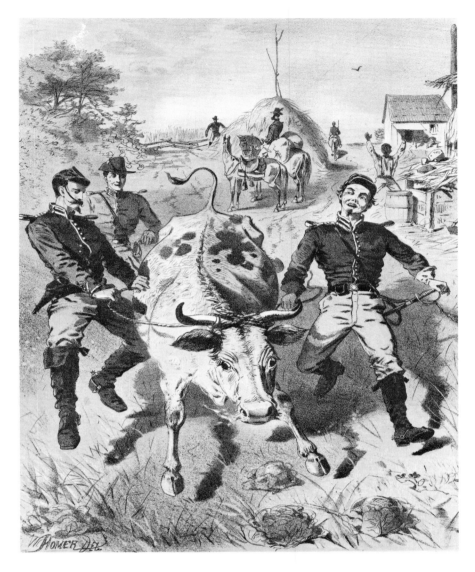

125. *Campaign Sketches: The Coffee Call.* 1863.
Lithograph, 14 x 10 ⅞″. Museum of Fine Arts,
Boston

126. *Campaign Sketches: Foraging.* 1863.
Lithograph, 14 x 10 ⅞″. Museum of Fine Arts,
Boston. Gift of Charles G. Loring

127. *Life in Camp. Part 1:*
Building Castles. 1864.
Lithograph, 4 1/8 x 2 1/2″.
Museum of Fine Arts, Boston

142

Twenty-four small lithographs
made up Homer's series *Life in*
Camp and were published by Prang
of Boston as souvenir cards.[60]

130. *Life in Camp. Part 1:*
Surgeon's Call. 1864.
Lithograph, 4 1/8 x 2 1/2″.
Museum of Fine Arts, Boston

AN UNWELCOME VISIT.

128. *Life in Camp. Part 1: An Unwelcome Visit.* 1864. Lithograph, 4 1/8 x 2 1/2″. Museum of Fine Arts, Boston

THE GUARD HOUSE.

129. *Life in Camp. Part 1: The Guard House.* 1864. Lithograph, 4 1/8 x 2 1/2″. Museum of Fine Arts, Boston

RIDING ON A RAIL.

131. *Life in Camp. Part 1: Riding on a Rail.* 1864. Lithograph, 4 1/8 x 2 1/2″. Museum of Fine Arts, Boston

A SHELL IS COMING.

132. *Life in Camp. Part 1: A Shell Is Coming.* 1864. Lithograph, 4 1/8 x 2 1/2″. Museum of Fine Arts, Boston

133. *Life in Camp. Part 1:*
Water Call. 1864.
Lithograph, 4 1/8 x 2 1/2''.
Museum of Fine Arts, Boston

134. *Life in Camp. Part 1:*
Upset His Coffee. 1864.
Lithograph, 4 1/8 x 2 1/2''.
Museum of Fine Arts, Boston

144

137. *Life in Camp. Part 1:*
Stuck in the Mud. 1864.
Lithograph, 4 1/8 x 2 1/2''.
Museum of Fine Arts, Boston

138. *Life in Camp. Part 1:*
Hard Tack. 1864.
Lithograph, 4 1/8 x 2 1/2''.
Museum of Fine Arts, Boston

TOSSING IN A BLANKET.

135. *Life in Camp. Part 1:*
Tossing in a Blanket. 1864.
Lithograph, 4 1/8 x 2 1/2''.
Museum of Fine Arts, Boston

LATE FOR ROLL CALL.

136. *Life in Camp. Part 1:*
Late for Roll Call. 1864.
Lithograph, 4 1/8 x 2 1/2''.
Museum of Fine Arts, Boston

IN THE TRENCHES.

139. *Life in Camp. Part 2:*
In the Trenches. 1864.
Lithograph, 4 1/8 x 2 1/2''.
Museum of Fine Arts, Boston

EXTRA RATION.

140. *Life in Camp. Part 2:*
Extra Ration. 1864.
Lithograph, 4 1/8 x 2 1/2''.
Museum of Fine Arts, Boston

THE RIFLE PIT.

141. *Life in Camp. Part 2:*
The Rifle Pit. 1864.
Lithograph, 4 1/8 x 2 1/2″.
Museum of Fine Arts, Boston

THE FIELD BARBER.

142. *Life in Camp. Part 2:*
The Field Barber. 1864.
Lithograph, 4 1/8 x 2 1/2″.
Museum of Fine Arts, Boston

DRUMMER.

143. *Life in Camp. Part 2:*
Drummer. 1864.
Lithograph, 4 1/8 x 2 1/2″.
Museum of Fine Arts, Boston

FORDING.

144. *Life in Camp. Part 2:*
Fording. 1864.
Lithograph, 4 1/8 x 2 1/2″.
Museum of Fine Arts, Boston

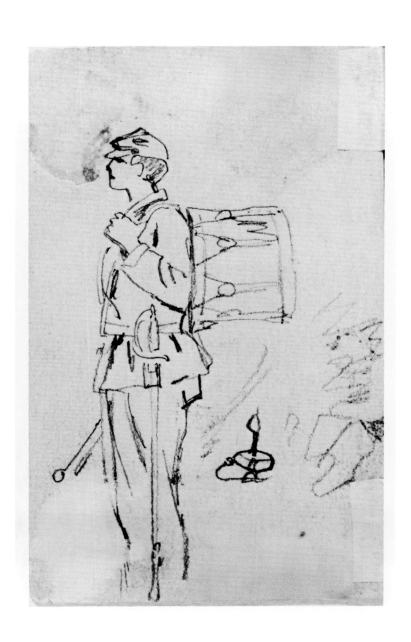

145. *Sketch of a Drummer.* 1862. Pencil, 4 1/2 x 2 3/4''.
Cooper-Hewitt Museum of Decorative Arts and Design,
Smithsonian Institution, New York City

HOME ON A FURLOUGH.

146. *Life in Camp. Part 2:*
Home on a Furlough. 1864.
Lithograph, 4 1/8 x 2 1/2″.
Museum of Fine Arts, Boston

THE GIRL HE LEFT BEHIND HIM.

147. *Life in Camp. Part 2:*
The Girl He Left Behind Him.
1864. Lithograph, 4 1/8 x 2 1/2″.
Museum of Fine Arts, Boston

148

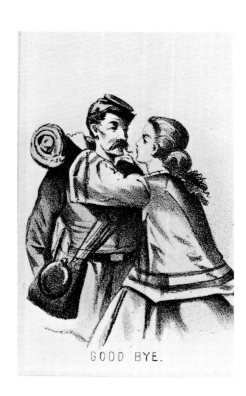

GOOD BYE.

149. *Life in Camp. Part 2:*
Good Bye. 1864.
Lithograph, 4 1/8 x 2 1/2″.
Museum of Fine Arts, Boston

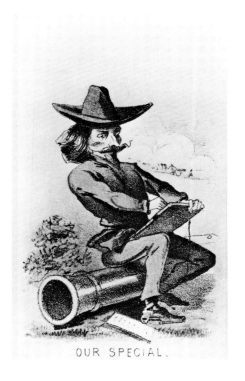

OUR SPECIAL.

150. *Life in Camp. Part 2:*
Our Special. 1864.
Lithograph, 4 1/8 x 2 1/2″.
Museum of Fine Arts, Boston

152. *Our Special Artist*. Portion of
News from the War (see Figure 53)

TEAMSTER.

148. *Life in Camp. Part 2:
Teamster*. 1864.
Lithograph, 4 1/8 x 2 1/2″.
Museum of Fine Arts, Boston

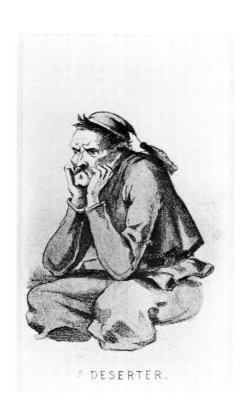

A DESERTER.

151. *Life in Camp. Part 2:
A Deserter*. 1864.
Lithograph, 4 1/8 x 2 1/2″.
Museum of Fine Arts, Boston

In *Our Special Artist*, appearing in the wood engraving *News from the War*, Homer's sincere, earnest side is clearly shown. There he portrays the artist reflecting upon his subject.

Our Special, from *Life in Camp*, shows he could laugh at himself, too.

Yet another aspect of his personality is brought out in another possible self-portrait, *Good Bye*, also from *Life in Camp*. Even here, Homer retained his sense of humor.

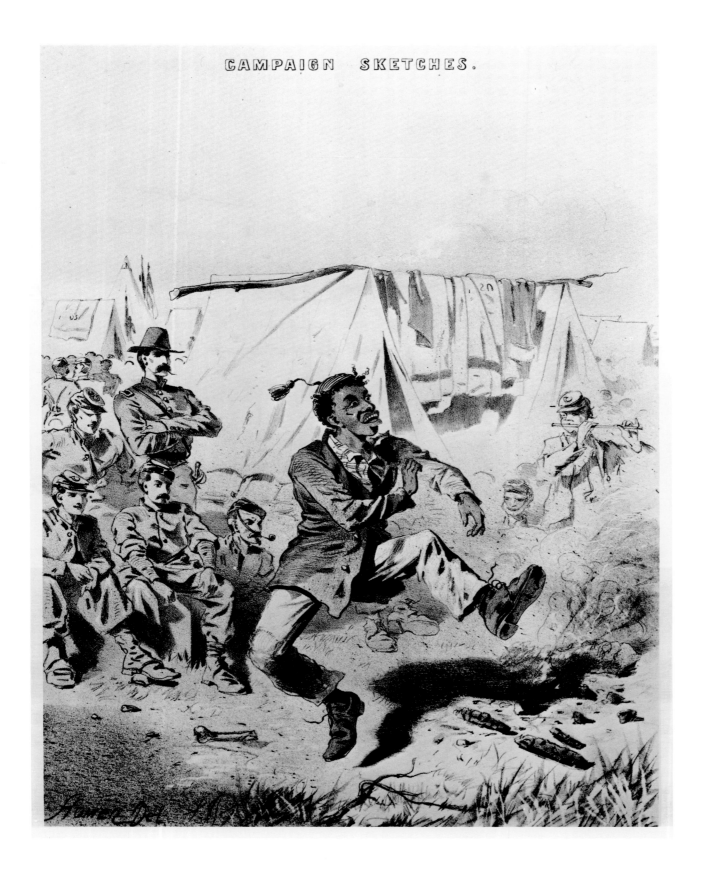

150

153. *Campaign Sketches: Our Jolly Cook.* 1863. Lithograph, 14 x 10 7/8". Prints Division, The New York Public Library. Astor, Lenox and Tilden Foundations

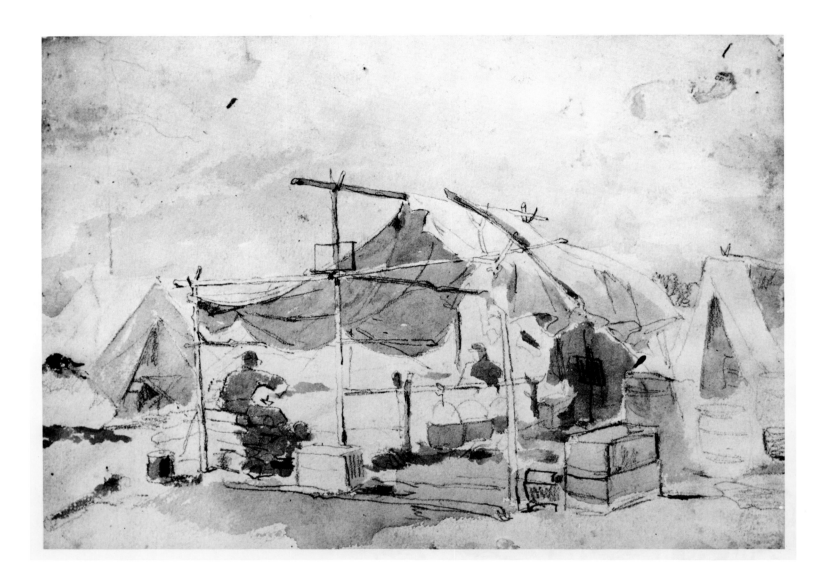

154. *Army Cook's Tent.*
1862. Pencil and gray and brown wash, 6 3/4 x 9 7/8". Cooper-Hewitt Museum of Decorative Arts and Design, Smithsonian Institution, New York City

Homer's depiction of the Negro reflected a limitation of the times. Nearly 200,000 freedmen served in a civilian status with the Union forces as teamsters, cooks, scouts, and so on. But Negroes were not only cooks and teamsters. The record shows that 178,985 enlisted men and 7,122 officers served in Negro regiments during the Civil War. This was nearly ten percent of the Union army. Of these soldiers the bare statistics tell their story: 37,300 gave "the last full measure of devotion."[61]

155. *View Across A Drill Ground with Log House and Tents in Foreground (Camp Winfield Scott).* 1862. Pencil on brown paper, 6 1/4 x 12 7/8″. Cooper-Hewitt Museum of Decorative Arts and Design, Smithsonian Institution, New York City

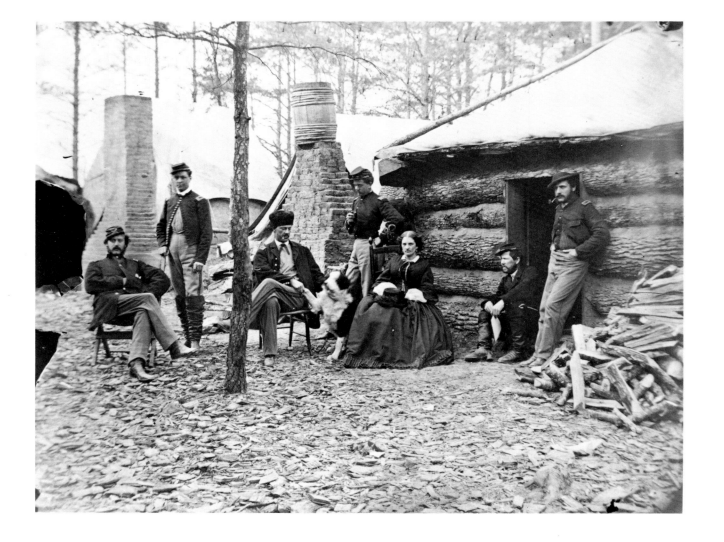

156. James F. Gibson. *Officers and Lady at Headquarters of 1st Brigade, Horse Artillery. Brandy Station, Virginia.* February, 1864. Photograph. Library of Congress, Washington, D.C. Mathew B. Brady Collection

157. *Clapboard Shack.* 1862. Pencil and
white gouache on blue paper, 6 1/8 x 9 1/2''.
Cooper-Hewitt Museum of Decorative Arts and
Design, Smithsonian Institution, New York City

Shelter, in the army as in civilian
life, was one of the necessities. Log
huts were more comfortable than tents,
and yet could be built in just a few
hours. They were made of rough logs,
mortared with mud, roofed with sod
or brush; sometimes a barrel served
as a chimney.[62]

158. *Sketch of Soldiers on the March.* c. 1864. Black and white chalk on light brown paper, 10 ⅞ x 15 ¼″. Cooper-Hewitt Museum of Decorative Arts and Design, Smithsonian Institution, New York City

159. *Infantry Column on the March.* 1862. Pencil on tracing paper,
10 1/4 x 23 1/2″. Cooper-Hewitt Museum of Decorative Arts and Design,
Smithsonian Institution, New York City

160. *Side View of Mounted Officer.* 1862. Pencil, 7 ⅝ x 6 ⅛". Cooper-Hewitt Museum of Decorative Arts and Design, Smithsonian Institution, New York City

Remarking on the fact that there are no insignia of rank visible in *Side View of Mounted Officer,* Edgar M. Howell of the Smithsonian suggests that "the low-crowned, non-regulation campaign hat would more likely be worn by an officer. The short 'shell' jacket is that authorized for mounted units. The shoulder gun appears to be the Burnside patent breech-loading carbine, and the edged weapon either the model 1840 heavy dragoon saber or the model 1860 light cavalry saber."[63]

161. *Mounted Cavalry Officer*. 1862. Pencil,
4 ³/4 x 3 ¹/2″. Cooper-Hewitt Museum of Decorative Arts
and Design, Smithsonian Institution, New York City

162. *Sketches of Officers*. 1862. Pencil, 9 ³/4 x 7″.
Cooper-Hewitt Museum of Decorative Arts and Design,
Smithsonian Institution, New York City

163. *Talbot's Battery*. 1862. Pencil, 6 ⁷/8 x 9 ¹/2″.
Cooper-Hewitt Museum of Decorative Arts and Design,
Smithsonian Institution, New York City

158

164. *Cavalry Soldier*. 1863.
Black chalk on brown paper, 14 1/4 x
7 7/8". Cooper-Hewitt Museum of
Decorative Arts and Design,
Smithsonian Institution,
New York City

165. *Soldier on Horseback.*
Date unknown. Charcoal and
white chalk on blue paper,
14 1/4 x 8 1/2''. Museum of
Fine Arts, Boston

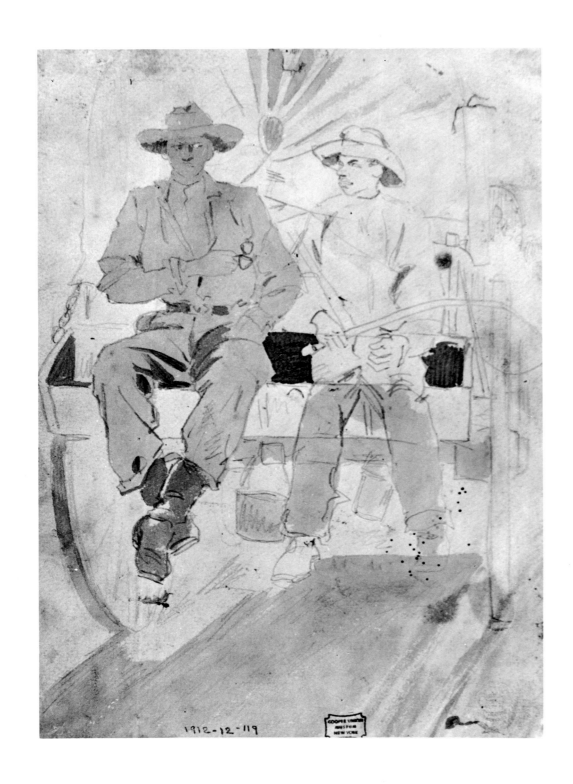

166. *An Army Wagon*. 1862.
Pencil and gray wash,
9 1/2 x 6 3/4". Cooper-Hewitt
Museum of Decorative Arts
and Design, Smithsonian
Institution, New York City

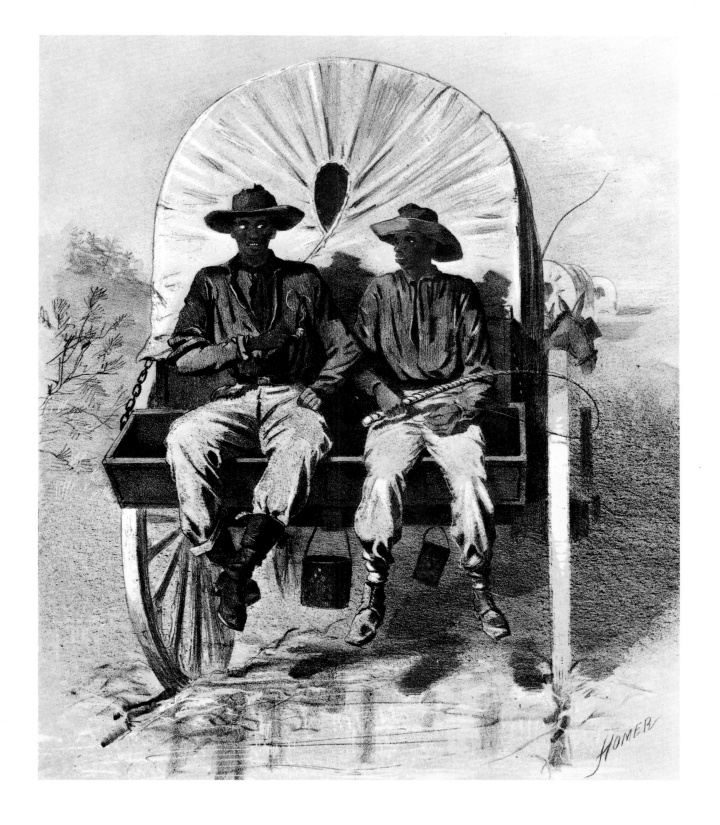

161

167. *Campaign Sketches: The Baggage Train.* 1863. Lithograph, 14 x 10 7/8″. Museum of Fine Arts, Boston

168. *Back of an Army
Wagon.* c. 1862. Pencil and
gray wash, 4 3/4 x 3 3/8''.
Cooper-Hewitt Museum of
Decorative Arts and Design,
Smithsonian Institution,
New York City

169. *Man Riding
Horse.* c. 1862. Pencil,
4 x 2 3/4''. Cooper-Hewitt
Museum of Decorative Arts
and Design, Smithsonian
Institution, New York City

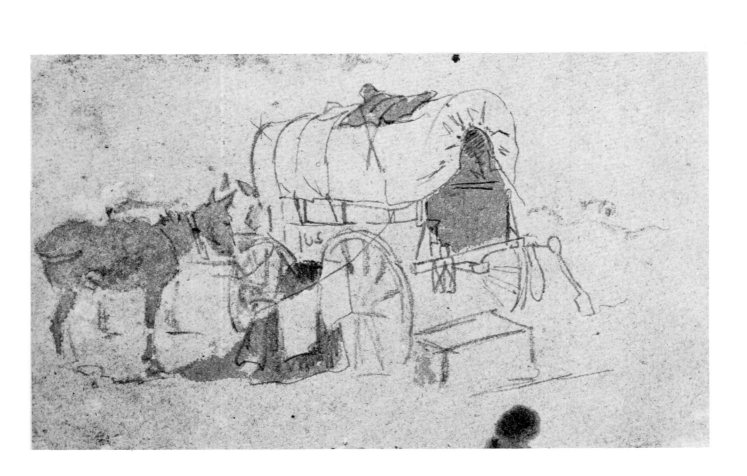

170. *Army Wagon.*
1862. Pencil and gray wash
on blue paper, 5 1/8 x 8 1/2''.
Cooper-Hewitt Museum of
Decorative Arts and Design,
Smithsonian Institution,
New York City

171. *Baggage Guard Defending the Supply Train.* 1865. Pen and ink, 9 x 18 ¼″.
Museum of Art, Carnegie Institute, Pittsburgh

In the most comprehensive history ever compiled of quartermaster support of the army, Erna Risch summarizes the logistics involved in field operations during the Civil War:

The wagon trains of an army consisted of the headquarters, the regimental, and the general supply trains. The supply trains operated between the principal base depots, to which points headquarters transferred clothing, rations and other stores by rail and water, and the temporary, smaller depots established in immediate proximity to an army, where authorized supply officers drew needed supplies and issued them to the troops.[64]

The large wagon trains made an imposing spectacle, and the wagoners themselves added to the excitement and movement. Many of the teamsters were hired civilians rather than soldiers. The Union supply trains, filled with rations and valuable war equipment, were often the target of Confederate cavalry raids.

172. *The Initials.* 1864. Oil on canvas, 15 1/2 x 11 1/2". Collection Dr. and Mrs. Irving Levitt, Southfield, Michigan

164

In 1864 Homer started to paint rural scenes, as if to escape from the monotony and restriction of illustrating only military life. A feeling of quietude pervades his New England scenes. The young people in the paintings are one with nature, and the viewer himself is put into a calm and thoughtful mood.

173. *Haymaking*. 1864. Oil on canvas,
16 x 11". The Columbus Gallery of Fine
Arts, Ohio. Howald Fund

174. *Train of Army Wagons.* 1862. Pencil, 3 1/2 x 4 7/8".
Cooper-Hewitt Museum of Decorative Arts and Design,
Smithsonian Institution, New York City

175. *Outlines of Wagon Train.* c. 1862. Pencil, 3 1/2 x 4 3/4".
Cooper-Hewitt Museum of Decorative Arts and Design,
Smithsonian Institution, New York City

176. *Resting Mules Tethered to
Wagon.* 1862. Pencil and gray
wash, 4 1/2 x 6 5/8". Cooper-Hewitt
Museum of Decorative Arts and
Design, Smithsonian Institution,
New York City

177. *Sketches of Mules.*
1862. Pencil, 9 1/2 x 6 3/4''.
Cooper-Hewitt Museum of
Decorative Arts and Design,
Smithsonian Institution,
New York City

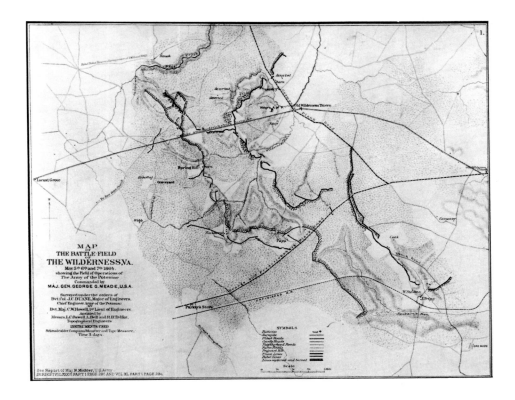

178. Map of the Battle of the Wilderness, from *Atlas to Accompany the Official Records of the Union and Confederate Armies*, published under the direction of the Secretaries of War (Washington, D.C.: Government Printing Office, 1891-95).

This map shows the Union line at right and the Confederate line at left in the first battle of the long and bloody Wilderness campaign, which lasted through the month of May and into early June of 1864.

168

omer was at the Battle of the Wilderness in the spring of 1864. Since he was attached to Major General Barlow's command, the artist's probable movements during this battle may be determined by following Barlow. From *Itinerary of the First Division, Second Army Corps*, we learn that on May 5, Barlow's division "marched to Todd's Tavern; thence by Brock road to Plank road to Orange Court-House, where we engaged the enemy."[65]

Homer's painting *A Skirmish in the Wilderness* gives some idea of the difficult terrain, in which dense thickets broke up battle lines and the enemy, more often than not, remained unseen. Assault was close and defense desperate in the tangled woods, where artillery could not be brought to bear.[66]

179. *A Skirmish in the Wilderness*. 1864. Oil on board, 18 x 26". New Britain Museum of American Art, Connecticut. Harriet Russell Stanley Memorial Fund

180. *"Any Thing for Me, If You Please?"*—
*Post-Office of the Brooklyn Fair in Aid
of the Sanitary Commission.* Published
in *Harper's Weekly*, March 5, 1864. Wood
engraving, 13 5/8 x 9 1/8". The Metropolitan
Museum of Art, New York City. Harris
Brisbane Dick Fund, 1929

181. *Army of the Potomac—Sleeping on Their Arms.* Published in *Harper's Weekly*, May 28, 1864. Wood engraving, 13 3/4 x 20 5/8″. The Metropolitan Museum of Art, New York City. Harris Brisbane Dick Fund, 1929

172

HOMER'S CREDO AS A PAINTER

From the time Homer first began to paint oil scenes of the war, he worked not in the studio but outdoors, in sunlight, on the roof of his New York studio building, where he utilized a mannequin dressed in military uniform. Years later in a rare utterance, printed in 1880 in *The Art Journal,* Homer stated his personal aversion to conventional studio pictures and his respect for going directly to life.

I prefer every time a picture composed and painted out-doors. The thing is done without your knowing it. Very much of the work now done in studios should be done in the open air. This making studies and then taking them home to use them is only half right. You get composition, but you lose freshness; you miss the subtle and, to the artist, the finer characteristics of the scene itself. I tell you it is impossible to paint an out-door figure in studio-light with any degree of certainty. Out-doors you have the sky overhead giving one light; then the reflected light from whatever reflects; then the direct light of the sun: so that, in the blending and suffusing of these several luminations, there is no such thing as a line to be seen anywhere.

I can tell in a second if an out-door picture with figures has been painted in a studio. When there is any sunlight in it, the shadows are not sharp enough; and, when it is an overcast day, the shadows are too positive. Yet you see these faults constantly in pictures in the exhibitions, and you know that they are bad.[69]

173

Earlier in the war, the Peninsular campaign had made the defenders of Richmond acutely aware of the need for fortifications around the city of Petersburg, through which came weapons, supplies, and food. The engineers of the Confederate army erected a chain of breastworks and artillery emplacements ten miles long; this was, in fact, ten times too long, given the available number of defenders. The dependence of Richmond upon Petersburg increased as the war went on.

In June of 1864, Grant began siege operations, making some gains. But by the end of October, after Grant was temporarily checked by Lee, field operations virtually ceased for the winter. Throughout November and December of 1864 and January of 1865, there were no strong efforts by either Confederate or Union forces before Petersburg; the most imminent danger faced by men on picket duty was from snipers' bullets.[67]

The defense of the main works in front of Petersburg, from the Plank Road to the Appomattox River (see map), was entrusted to the First Division, Second Army Corps, commanded by Brigadier General Barlow.[68]

174

183. Map of U.S. Forces at Petersburg, Virginia, from *Atlas to Accompany the Official Records of the Union and Confederate Armies*, published under the direction of the Secretaries of War (Washington, D.C.: Government Printing Office, 1891-95).

184. Sketches for the painting *Defiance*. 1864. Pencil and white chalk on brown paper, 9 1/2 x 13 1/8".
Cooper-Hewitt Museum of Decorative Arts and Design, Smithsonian Institution, New York City

185. *Defiance: Inviting a Shot Before Petersburg, Virginia.* 1864. Oil on panel, 12 x 18″. Detroit Institute of Arts. Gift of Dexter M. Ferry, Jr.

Defiance: *Inviting a Shot Before Petersburg* is reminiscent of an ancient American Indian battle custom. A warrior, when feeling his boldness, or perhaps driven by sheer boredom, would plant his coupstick where he stood, and invite the battle to begin. It was now or never, there or die.

A certain degree of uncertainty exists about this picture. As Mr. Howell, Curator of Military History at the Smithsonian, has pointed out, the details are indistinct. The military uniforms and headgear appear to be nonregulation. Except for the fact that Homer is known to have worked only with the Union army, one might think these to be Confederates from their nondescript dress and from the presence of a black banjo player in their midst who could just as easily be a faithful slave as a "contraband."[70]

What is important about Homer's portrayal of this scene is that it could be either army. The same pressures and tensions were operating on both sides of the narrow no-man's-land in front of Petersburg.

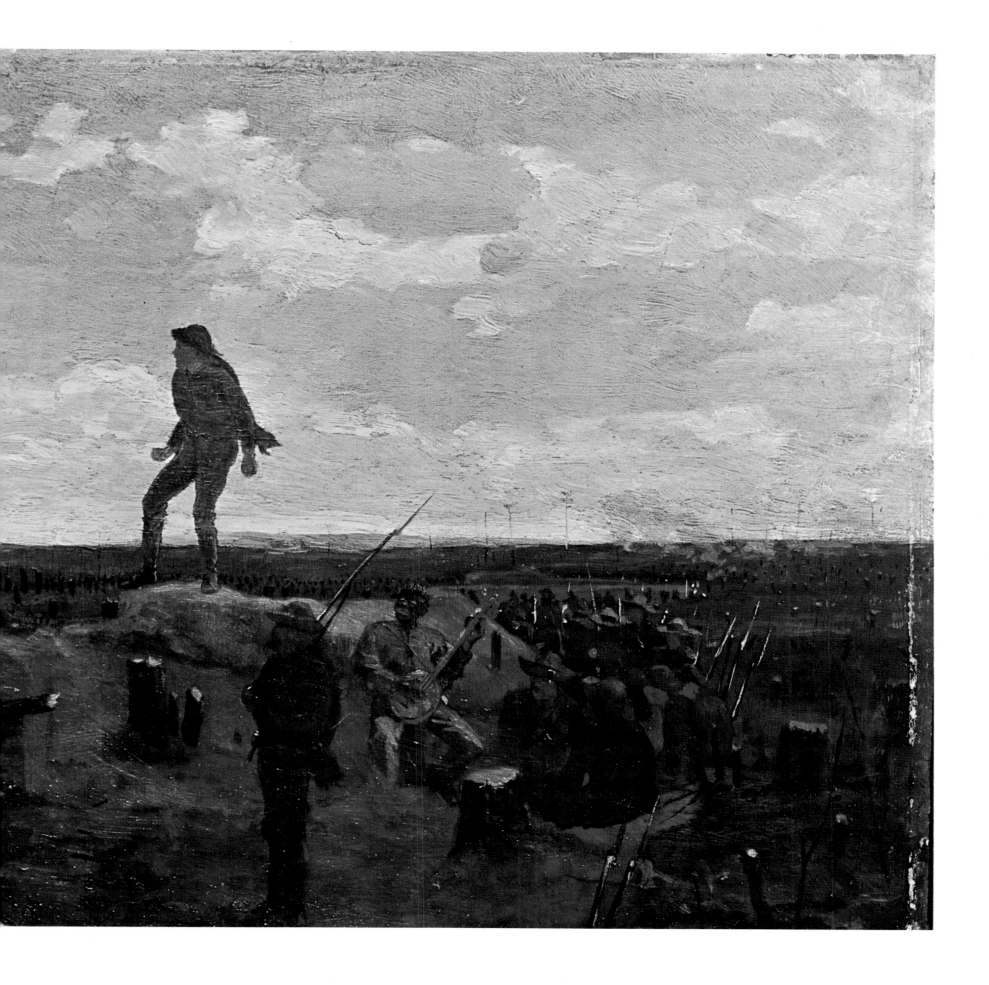

177

Life in camp on Thanksgiving Day, 1864: Could these grizzled old veterans be wishing for peace? Homer has placed the fragile wishbone on the central axis between the two contestants. The man at far right, derived from an earlier drawing, *Soldier with Pipe in Mouth* (Fig. 116), stoops forward in anticipation of the outcome.

186. *Thanksgiving-Day in the Army—After Dinner: The Wish-Bone.* Published in *Harper's Weekly*, December 3, 1864. Wood engraving, 9 1/4 x 13 7/8″. The Metropolitan Museum of Art, New York City. Harris Brisbane Dick Fund, 1929

PART 3

WAR'S END

1865

187. *The Return of Sheridan's Troops.* 1865. Pencil, 15 3/8 x 21 7/8".
Addison Gallery of American Art, Phillips Academy, Andover, Massachusetts

188. *Relief of the Outer Picket.* Date unknown. Pen and ink, 15 1/2 x 21 3/4''. Museum of Art, Carnegie Institute, Pittsburgh

189. *Escort of a General.* Date unknown. Pen and ink, 9 x 15''. Museum of Art, Carnegie Institute, Pittsburgh

190. *Two Federal Scouts.*
1887. Watercolor, 27 x 21".
Collection James H. Weekes,
Kilbride, County Wicklow,
Ireland

This watercolor,
showing Northern scouts
disguised in Confederate
uniforms, was painted
almost twenty years after
the war ended. In a letter
to the man who commissioned
the painting, Homer noted
that he had originally drawn
the figures "from life when
in advance of the Army on
its last campaign, March 28,
1865."[72]

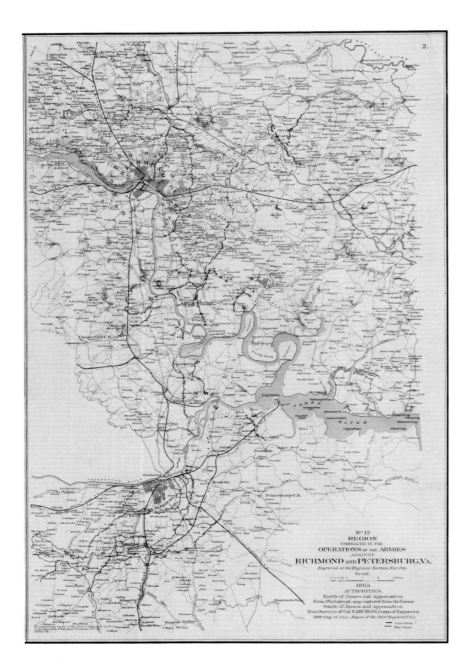

191. Map of Richmond-Petersburg region, from *Atlas to Accompany the Official Records of the Union and Confederate Armies*, published under the direction of the Secretaries of War (Washington, D.C.: Government Printing Office, 1891-95).

The Confederate Army under Lee made its last stand in this area from June, 1864, to April, 1865. The two cities and the connecting rail line were defended by strongly entrenched Confederate troops. The Union Army, commanded by Grant, took up positions to the east, using the James River and the City Point railhead (center right) as its main supply route.

At the time of the vernal equinox, 1865, Grant saw the end in sight and mustered his forces for a grand drive. During the long siege of Petersburg, Lee had been forced to counter Grant's extension of the Union line by stretching his own meager defenses.

Lee also foresaw that with the coming of spring his attenuated line, extending for thirty-five miles, would be broken by superior numbers. On March 25, 1865, he assaulted Fort Stedman, desperately attempting to penetrate Grant's right and cut off the Union supply railroad to City Point. The attack failed.[71]

It is at the railroad station in City Point that we see Grant, along with Lincoln and his son Tad, probably between March 25th and April 1st. At first glance it would seem a pity that Homer was not more attracted to this wonderful opportunity to depict the visages of the two leaders, but he was never very impressed by position or power. His true interest lay in the human aspect. Here he catches Lincoln in the very human act of a father holding his son by the hand.

The Southern defenses were overtaxed, and Lee was unable to break out; this was the situation Grant had sought. On April 1, 1865, he attacked at Five Forks, sixteen miles southwest of Petersburg. The Confederate line bent and broke. That night the Army of Northern Virginia abandoned the Richmond-Petersburg trenches and slowly moved westward in retreat. Grant gave chase.

Lee's retreat ended on Palm Sunday, April 9, 1865, at Appomattox.

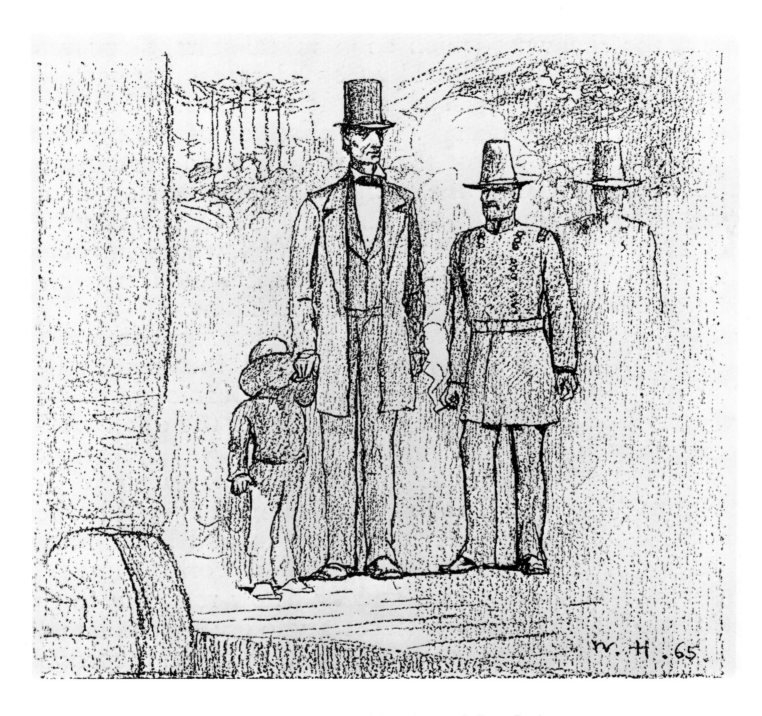

192. *President Lincoln, General Grant, and Tad Lincoln at a Railway Station.*
(Sketched from Life by Winslow Homer [1865]*).* Published in *The Century Magazine*, November, 1887.
Wood engraving, 2 7/8 x 3″. Library of Congress, Washington, D.C.

193. *Holiday in Camp—Soldiers Playing "Foot-Ball."* Published in *Harper's Weekly*, July 15, 1865.
Wood engraving, 9 1/4 x 13 3/4". The Metropolitan Museum of Art, New York City. Harris Brisbane Dick Fund, 1936

194. *Our Watering-Places—The Empty Sleeve at Newport.* Published in *Harper's Weekly*, August 26, 1865.
Wood engraving, 9 1/4 x 13 3/4''. The Metropolitan Museum of Art, New York City. Harris Brisbane Dick Fund, 1936

188

195. *Thanksgiving Day—Hanging Up the Musket*. Published in *Frank Leslie's Illustrated Newspaper*, December 23, 1865. Wood engraving, 14 1/8 x 9 1/8″. Prints Division, The New York Public Library. Astor, Lenox and Tilden Foundations

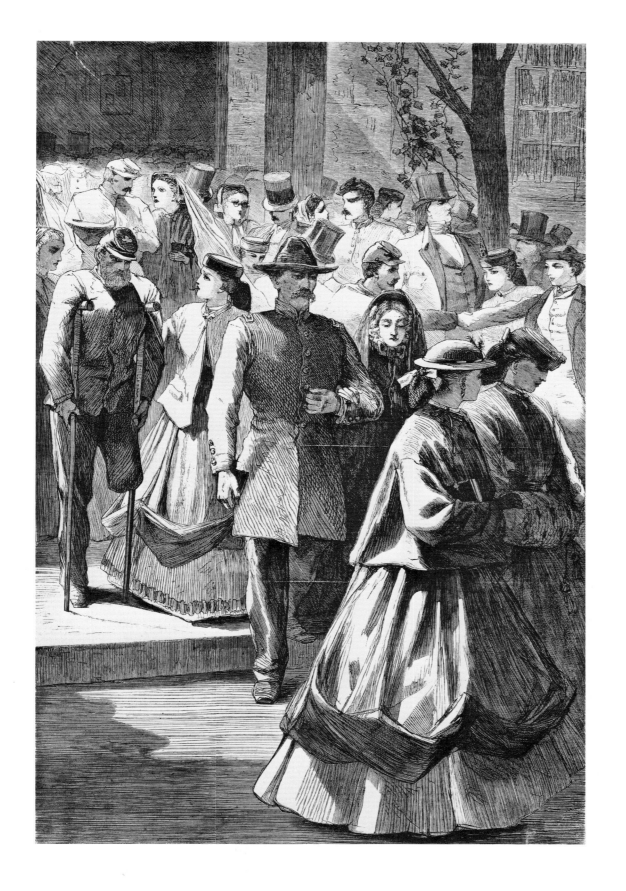

196. *Thanksgiving Day—The Church Porch.* Published in *Frank Leslie's Illustrated Newspaper,* December 23, 1865. Wood engraving, 13 ⁷/8 x 9 ¹/8''. Prints Division, The New York Public Library. Astor, Lenox and Tilden Foundations

190

197. *The Veteran in a New Field.* 1865. Oil on canvas, 24 x 38″.
The Metropolitan Museum of Art, New York City. Bequest of
Adelaide Milton de Groot, 1967

PART 4

EPILOGUE

Five Years After

Looking back from the vantage point of a handful of years, Homer saw that at least three crucial events had taken place in the decade from 1860 to 1870. In order of ascending importance they were:

1. The U.S.S. *Monitor* and the C.S.S. *Virginia* signaled an end to the age of wood and sail and opened up an age of iron and steam. Navies were now able to operate unhampered by wind, tide, or current. The Civil War also marked the first United States use of balloon reconnaissance from ships. Today the United States Navy sees this as ancestral to the Fast Carrier Task Forces.[73]

2. Lincoln issued the Emancipation Proclamation. Seen in retrospect, it appeared that the most important result, even the aim, of the war had been the freeing of the slaves; the black

American had held this from the first.[74]

3. The armies laid down their weapons; the men could go back to productive work. Most important of all, black and white children were to go to school side by side. Children—black and white—were the hope of the future.

The Tennyson verses from "In Memoriam" accompanying this plate sum up Homer's aspirations for America's future:

Ring out a slowly dying cause,
 And ancient forms of party strife;
 Ring in the nobler modes of life,
With sweeter manners, purer laws. . . .

Ring out false pride in place and blood,
 The civic slander and the spite;
 Ring in the love of truth and right,
Ring in the common love of good.

198. *1860—1870*. Published in *Harper's Weekly*, January 8, 1870. Wood engraving, 13 x 20 3/8″.
Prints Division, The New York Public Library. Astor, Lenox and Tilden Foundations

1. *The New Path* (1863), periodical published by Society for the Advancement of Truth in Art. As quoted in: Albert Ten Eyck Gardner, *Winslow Homer, American Artist: His World and His Work* (New York: Clarkson N. Potter, 1961), p. 78.

2. Lloyd Goodrich, *Winslow Homer* (New York: George Braziller, 1959), p. 13.

3. A. Hyatt Mayor, *Prints; The Metropolitan Museum of Art Guide to the Collections* (New York: Metropolitan Museum, 1964), p. 29.

4. Lloyd Goodrich, *Winslow Homer* (Braziller), p. 32.

5. Allen Weller, "Homer's Early Illustrations for *Harper's Weekly*," *American Magazine of Art*, vol. 28 (July, 1935), pp. 412-17.

6. Kenneth M. Stampp, ed., *The Causes of the Civil War* (Englewood Cliffs, N.J.: Prentice-Hall, 1965).

7. Abraham Lincoln, "Address at Cooper Institute, New York," in *The Life and Writings of Abraham Lincoln*, ed. Philip Van Doren Stern (New York: Modern Library, 1940), pp. 590-91.

8. *Abraham Lincoln: An Exhibition at the Library of Congress in Honor of the 150th Anniversary of His Birth* (Washington, D.C.: Government Printing Office, 1959), pp. 34-35.

9. Frank Luther Mott, *A History of American Magazines*, vol. II, 1850-65 (Cambridge, Mass.: Harvard University Press, 1938), p. 475.

10. Carl Sandburg, "The Face of Lincoln," in *The Photographs of Abraham Lincoln*, by Frederick Hill Meserve and Carl Sandburg (New York: Harcourt, Brace, 1944), p. 10.

11. From John C. Nicolay's writings as included in Meserve and Sandburg, *The Photographs of Abraham Lincoln*, pp. 5-6.

12. From Horace White's writings as included in Meserve and Sandburg, *The Photographs of Abraham Lincoln*, p. 12.

13. Elizabeth A. W. Dwight, *The Life and Letters of Wilder Dwight* (Boston: Ticknor & Fields, 1868), pp. 33-34.

14. *Harper's Weekly*, May 11, 1861, p. 289.

15. Walt Whitman, "National Uprising and Volunteering," in *Specimen Days*, from *Complete Prose Works* (Boston: Small, Maynard & Co., 1891), p. 16.

16. William Todd, *The Seventy-ninth Highlanders New York Volunteers in the War of the Rebellion 1861-1865* (Albany: 1886), pp. 1, 5.

17. Walt Whitman, "Contemptuous Feeling," in *Specimen Days*, pp. 16-17.

18. Walt Whitman, "Battle of Bull Run," in *Specimen Days*, pp. 17-18.

19. *Harper's Weekly*, July 13, 1861, p. 443.

20. Samuel Eliot Morison and Henry Steele Commager, *The Growth of the American Republic* (New York: Oxford University Press, 1962), vol. I, p. 706.

21. *Harper's Weekly*, July 20, 1861, p. 449.

22. Joseph P. Cullen, "The Army of the Potomac," in *Richmond National Battlefield Park, Virginia*, National Park Service Historical Series No. 33 (Washington, D.C.: Government Printing Office, 1961).

23. *The American Civil War: A Centennial Exhibit at the Library of Congress* (Washington, D.C.: Government Printing Office, 1961), p. 62.

24. Bruce Catton, *This Hallowed Ground* (New York: Doubleday, Pocket Cardinal edition, 1956), p. 32.

25. Benjamin Quarles, *The Negro in the Civil War* (Boston: Little, Brown & Co., 1969), pp. v-viii, 57-77.

26. Butler to Lieutenant General Winfield Scott, May 25, 1861, *Private and Official Correspondence of Gen. Benjamin F. Butler During the Period of the Civil War*, vol. I (privately issued, 1917), pp. 105-7.

27. Cary to Butler, March 19, 1891, ibid., pp. 102-3.

28. Simon Cameron, Secretary of War, to Butler, May 30, 1861, p. 119.

29. *The American Civil War: A Centennial Exhibit at the Library of Congress*, p. 15.

30. Joseph P. Cullen, "The Peninsular Campaign, Summer 1862," *Richmond National Battlefield Park, Virginia.*

31. Allen E. Foster, "Check List of Illustrations by Winslow Homer," *Bulletin of the New York Public Library*, vol. 40, October, 1936, pp. 842-52. See also *Supplement*, vol. 44, July, 1940, pp. 537-39.

32. *Album of American Battle Art 1775-1918* (Washington, D.C.: Library of Congress, 1947).

33. Report of Colonel Francis C. Barlow, Sixty-first Regiment, New York Volunteers, Caldwell's Brigade, Richardson's Division to Captain C. H. Potter, Assistant Adjutant General, Robinson's Brigade, Kearny's Division, July 3, 1862, in *The War of the Rebellion: Compilation of the Official Records of the Union and Confederate Armies* (Washington, D.C.: Government Printing Office, 1901), series I, vol. XI, pt. II, p. 65.

34. Civil War Centennial Commission, *Facts about the Civil War* (Washington, D.C.: Government Printing Office, 1960), p. 9.

35. Stephen F. Mason, *A History of the Sciences* (New York: Collier Books, 1962), pp. 503-5.

36. Job 39:19-25, The Holy Scriptures according to the Masoretic Text (Philadelphia: The Jewish Publication Society of America, 1917).

37. Stephen Crane, *The Red Badge of Courage* (Appleton, 1895; Random House, Modern Library edition, 1951), p. 65.

38. Civil War Centennial Commission, *Facts about the Civil War*, p. 10.

39. Francis A. Lord, *They Fought for the Union* (New York: Crown Publishers, 1969), pp. 73-77.

40. James I. Robertson, Jr., *The Civil War* (Washington, D.C.: Government Printing Office for the U.S. Civil War Centennial Commission, 1963), p. 35.

41. Richard H. Shryock, "The Nationalistic Tradition of the Civil War: A Southern Analysis," *South Atlantic Quarterly*, vol. 32 (July, 1933), pp. 294-305.

42. Walt Whitman, "Hospital Scenes and Persons," in *Specimen Days*, p. 23.

43. Walt Whitman, "My Preparations for Visits," in *Specimen Days*, p. 32.

44. Lloyd Goodrich, *Winslow Homer* (New York: Macmillan, 1944), p. 18.

45. Edgar M. Howell, Curator, Division of Military History, The National Museum of History and Technology, Smithsonian Institution, Washington, D.C., personal communication, May 4, 1970.

46. Lloyd Goodrich, *Winslow Homer* (Macmillan), p. 18.

47. Frank Wilkeson, *Recollections of a Private Soldier in the Army of the Potomac* (New York: Putnam, 1887), pp. 30-36.

48. *The American Civil War: A Centennial Exhibit at the Library of Congress*, p. 7.

49. Bruce Catton, *Mr. Lincoln's Army* (New York: Doubleday, 1951), p. 40.

50. See note 45 above.

51. Henry T. Tuckerman, *Book of the Artists; American Artist Life* (New York: Putnam, 1867), pp. 18, 491.

52. Ibid., p. 624; *Dictionary of American Biography*, s.v. "Johnston, John Taylor."

53. Clarence Cook, *Art and Artists of Our Time* (New York: S. Hess, 1888), vol. 3, p. 256.

54. See note 45 above.

55. *Dictionary of American Biography*, s.v. "Barlow, Francis Channing."

56. Ulysses Simpson Grant, *Personal Memoirs of U.S. Grant* (New York: C. L. Webster & Co., 1886), vol. 2, p. 270.

57. Sheldon B. Thorpe, *History of the Fifteenth Con-*

necticut Volunteers (New Haven: Price, Lee & Adkins Co., 1893), p. 41.

58. Bell Irvin Wiley, *They Who Fought Here* (New York: Macmillan, 1959), pp. 42-43.

59. Associated Press dispatch datelined Berkeley, Va., June 29, 1869.

60. Lloyd Goodrich, *The Graphic Art of Winslow Homer* (New York: Museum of Graphic Art, 1968), p. 10.

61. James M. McPherson, *The Negro's Civil War* (New York: Pantheon Books, 1965), pp. 143, 237.

62. *The American Civil War: A Centennial Exhibit at the Library of Congress*, p. 10.

63. See note 45 above.

64. Erna Risch, *Quartermaster Support of the Army; A History of the Corps, 1775-1939* (Washington, D.C.: Quartermaster Historian's Office, Office of the Quartermaster General, 1962), p. 421.

65. *The War of the Rebellion*, series I, vol. XXXVI, pt. I, p. 369.

66. Joseph P. Cullen, *Where a Hundred Thousand Fell*, National Park Service Historical Handbook Series No. 39 (Washington, D.C.: Government Printing Office, 1966); Maurice Matloff, ed., *American Military History*, Army Historical Series (Washington, D.C.: Office of the Chief of Military History, U.S. Army, 1969), p. 206.

67. Richard Wayne Lykes, *Petersburg Battlefields; Petersburg National Military Park, Virginia*, National Park Service Historical Handbook Series No. 13 (Washington, D.C.: Government Printing Office, 1956).

68. Colonel M. I. Ludington to Brevet Major General M. C. Meigs, Quartermaster General U.S. Army, September 9, 1865, *The War of the Rebellion*, series III, vol. v, p. 482.

69. "Sketches and Studies; from the Portfolios of A.H. Thayer, William M. Chase, Winslow Homer, and Peter Moran," *The Art Journal* (1880), vol. 6, p. 107.

70. See note 45 above.

71. *Concise Dictionary of American History* (New York: Scribner's, 1962), s.v. "Petersburg, Siege of."

72. Winslow Homer to James J. Higginson, December 12, 1887, in Hermann Warner Williams, Jr., *The Civil War: The Artists' Record* (Washington, D.C.: The Corcoran Gallery of Art, 1961).

73. *The United States Navy* (Washington, D.C.: Naval History Division, Navy Department, 1969), p. 21.

74. Benjamin Quarles, *The Negro in the Civil War*, p. vii.

BIBLIOGRAPHY

For fullest understanding of my ideas and for a deeper appreciation of Homer's work, I suggest reading other writers on the Civil War and particularly primary source material: narratives, diaries, and so on. Much of art is, after all, an auxiliary method of recording history.—J.G.

LIST OF BIBLIOGRAPHIES

Lord, Francis A. *They Fought for the Union.* New York: Crown Publishers, 1969. Dependent bibliography comprising chapter 22: "Civil War Bibliography."

Munden, Kenneth W., and Beers, Henry Putney. *Guide to Federal Archives Relating to the Civil War.* Washington, D.C.: National Archives, 1962. A comprehensive, independent bibliography dealing with the records of the United States Government.

Wiley, Bell Irvin. *The Life of Billy Yank.* New York: Bobbs-Merrill Co., 1952. Dependent bibliography at end of book: "Bibliographical Notes."

MONOGRAPHS ON HOMER

Beam, Philip C. *Winslow Homer at Prout's Neck.* Boston: Little, Brown & Co., 1966.

Cowdrey, Mary Bartlett. *Winslow Homer: Illustrator.* Northampton, Mass: Smith College Museum of Art, 1951.

Downes, William Howe. *The Life and Works of Winslow Homer.* Boston: Houghton Mifflin, 1911.

Flexner, James. *The World of Winslow Homer.* New York: Time-Life Books, 1966.

Gardner, Albert Ten Eyck. *Winslow Homer, American Artist: His World and His Work.* New York: Clarkson N. Potter, 1961. Bountiful illustrations.

Gelman, Barbara, ed. *The Wood Engravings of Winslow Homer.* New York: Crown Publishers, 1969. Pictorially comprehensive.

Goodrich, Lloyd. *The Graphic Art of Winslow Homer.* New York: Museum of Graphic Art, 1968.

———.*Winslow Homer.* New York: Macmillan, 1944. The standard biography of Homer.

———.*Winslow Homer.* New York: George Braziller, 1959.

———.*Winslow Homer's America.* New York: Tudor Publishing Co., 1969.

Hoopes, D. F. *Winslow Homer Watercolors.* New York: Watson-Guptill Publications, 1969.

HISTORICAL WORKS
AND
ART BOOKS

Album of American Battle Art, 1755-1918. Washington, D.C.: Library of Congress, 1947.

American Battle Paintings, 1776-1918 (exhibition catalogue). Washington, D.C.: National Gallery of Art, 1944.

The American Civil War: A Centennial Exhibit at the Library of Congress. Washington, D.C.: Government Printing Office, 1961.

Boatner, Mark Mayo, III. *The Civil War Dictionary.* New York: McKay, 1959.

Bramson, Leon, and Goethals, George W., eds. *War; Studies from Psychology, Sociology, Anthropology.* New York: Basic Books, 1968. See especially articles by Margaret Mead and Bronislaw Malinowski.

The Civil War: A Centennial Exhibition of Eyewitness Drawings. Washington, D.C.: National Gallery of Art, Smithsonian Institution, 1961.

Facts about the Civil War. Prepared by the Civil War Centennial Commission. Washington, D.C.: Government Printing Office, 1960.

Flexner, James Thomas. *That Wilder Image: The Painting of America's Native School from Thomas Cole to Winslow Homer.* Boston: Little, Brown & Co., 1962.

Freeman, Douglas Southall. *R. E. Lee: A Biography.* New York: Scribner's, 1934.

Glover, R. "War and the Civilian Historian." *Journal of the History of Ideas.* January 1957, pp. 84-100.

Korn, Bertram W. *American Jewry and the Civil War.* Introduction by Allan Nevins. Philadelphia: The Jewish Publication Society of America, 1951.

Morison, Samuel Eliot, and Commager, Henry Steele. *The Growth of the American Republic.* Vol. I. New York: Oxford University Press, 1962.

Quarles, Benjamin. *The Negro in the Civil War.* Boston: Little, Brown & Co., 1969.

Risch, Erna. *Quartermaster Support of the Army; a History of the Corps 1775-1939.* Washington, D.C.: Quartermaster Historian's Office, Office of the Quartermaster General, Department of the Army (Government Printing Office), 1962.

Robertson, James I., Jr., for the U.S. Civil War Cen-

tennial Commission. *The Civil War.* Washington, D.C.: Government Printing Office, 1963.

Stampp, Kenneth M., ed. *The Causes of the Civil War.* Englewood Cliffs, N.J.: Prentice-Hall, 1965.

Thomas, Benjamin. *Abraham Lincoln.* New York: Modern Library, 1952.

Uniform Regulations for the Army of the United States 1861. Washington, D.C.: Smithsonian Institution, 1961. Illustrated with contemporary official War Department photographs; introduction by Edgar M. Howell.

The War of the Rebellion: Compilation of the Official Records of the Union and Confederate Armies. Washington, D.C.: Government Printing Office, 1901.

Whitman, Walt. *Complete Prose Works.* Boston: Small, Maynard & Co., 1891.

————.*Walt Whitman's Civil War.* Compiled and edited by Walter Lowenfels. New York: Alfred A. Knopf, 1960.

Wiley, Bell Irvin. *They Who Fought Here.* New York: Macmillan, 1959.

Williams, Hermann Warner, Jr. *The Civil War: The Artists' Record* (exhibition catalogue). Washington, D.C.: The Corcoran Gallery of Art, 1961.

CREDITS

The author and publisher wish to thank the libraries, museums, and private collectors for permitting the reproduction of paintings, prints, drawings, photographs, and maps in their collections. Photographs have been supplied by the owners or custodians of the works except for the following, whose courtesy is gratefully acknowledged:

Beville, Henry, Alexandria, Va., 1, 52, 76, 81; Blomstrann, E. Irving, New Britain, Conn., 179; Clements, Geoffrey, New York City, 28, 41, 47, 55, 60, 63, 73, 74, 79, 83, 114, 122, 157, 162, 197; Dann Studios, Dublin, Ireland, 190; Hickey and Robertson, Houston, Tex., 182; Klima, Joseph, Detroit, Mich., 105, 176; Library of Congress, Washington, D.C., 35, 36, 178, 183, 191.